the photographer's guide to Vermont

Where to Find Perfect Shots and How to Take Them

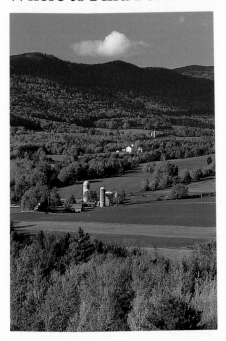

David Middleton

THE COUNTRYMAN PRESS
WOODSTOCK, VERMONT

Library of Congress Cataloging-in-Publication Data:

Middleton, David, 1955–
 The photographer's guide to Vermont : where to find perfect shots and how to take them / David Middleton.—1st ed.
 p. cm.
 Includes bibliographical references.
 ISBN 0-88150-533-1
 1. Vermont—Guidebooks. 2. Vermont—Pictorial works. 3. Photography—Vermont—Handbooks, manuals, etc. I. Title.
F47.3.M53 2003
917.4304'44—dc21 2003048595

Cover and interior photos by the author unless otherwise indicated
Photos on pages 7, 21, 44, 47, 77, and 82 and back cover photo of Cloudland Farm © Kim Grant, www.kimgrant.com
Cover and interior design by Susan Livingston
Maps by Paul Woodward, © The Countryman Press

Published by The Countryman Press, P.O. Box 748, Woodstock, Vermont 05091
Distributed by W. W. Norton & Company, Inc., 500 Fifth Avenue, New York, NY 10110

Printed in China

10 9 8 7 6 5 4 3 2 1

To all of my students

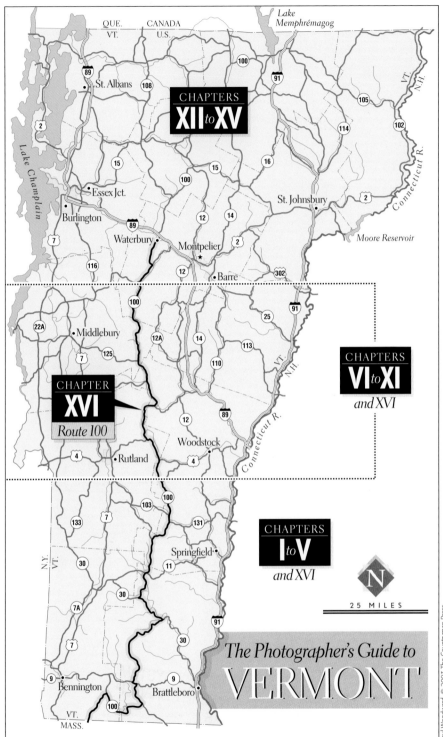

The Photographer's Guide to

VERMONT

Contents

Introduction

If you think about Vermont and all the pictures you've ever seen of the state, you might get the impression that it's full of white-clapboard churches in quaint villages where quaint villagers work in colorful forests. Well, come to think of it, that is a pretty good impression of the state. Vermont is, in fact, chock-full of pretty little villages in picturesque settings. You'd have a hard time driving more than 10 miles in any direction without bumping into a country store, a village green, or a real-live Vermonter doing real-live Vermonter things.

But there's more to Vermont than just quintessential New England scenery. There are wild forests with clear, tumbling streams, craggy mountains (some of which have roads to the top), beautiful wildflowers, great congregations of geese, covered bridges, apple orchards, old barns, miles of back roads, bogs, orchids, moose, country fairs, lakes of all sizes, meandering rivers, more sheep, cows, and draft horses than you can count, and old stone walls wherever you look. In other words, there is much to enchant a photographer here.

There are two ways you can go about photographing Vermont. The wrong way is to rush out and blast away with your camera at everything you see, going to the same old spots and doing things the same old way. You'd get some good shots this way, but you'd also get a lot of duds and trash-can fillers. And you'd miss some opportunities for spectacular photographs at Vermont's little-known but very pretty spots.

The right way to photograph Vermont

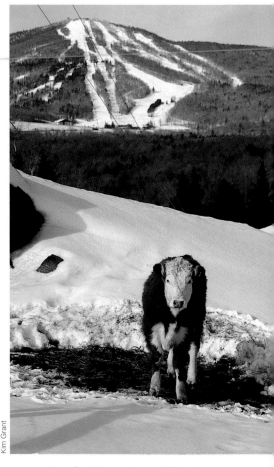

Kim Grant

Bromley Mountain and friend

is to sit back, grab a map, and read this book before you start crashing around. There are lots of great locations included in this book, with lots of great tips on how to get the most out of your photography. So instead of running around with Willie Nilly as your navigator, pull up a chair, put your feet up, and let me make a few suggestions that just might help you get some great shots. Besides, Willie Nilly is a crummy map reader.

Using This Book

This book evolved out of my students' incessant questions about the best places to photograph in Vermont. Believing that I would actually tell them the truth, they'd give me maps and blank pages and I'd begin describing areas and highlighting roads for them to explore. But it was never that easy. There was always more to tell them and more places to suggest they go. Vermont is a rich place for photographers.

This book is my final answer to their questions. It includes all my favorite places to photograph in Vermont. I didn't leave out any extra-secret places (at least none that you would know about), and I have included all the best-known locations in the state. The only place I purposely excluded was my backyard and, quite frankly, I don't want to see you there. There are plenty of other places to take pictures in here; no need to come over and annoy me.

As well as a description of each place, I've included information on its seasonal variations and when the best times might be to visit. This is done with a bit of trepidation, because the seasons can vary so much from year to year. Still, in general, if you go during my suggested times you will find good things to photograph. I have rated each of the seasons on a scale of 1–4 stars (4 being the best) to help you get a feel for the photography. A 4-star rating indicates one of my favorite places to go in that season.

As to what to do once you get to the location, I've included some suggestions under Pro Tips. These are the things I generally do at each location, and you're welcome to do the same or ignore them altogether. Under Cautions I've listed the things you *don't* want to do at the site. Some are physical features to be careful about, and some are photographic things to watch out for and avoid. In the back of the book is a list of other reference books that I have found very helpful, along with an even longer list of favorite things that didn't quite fit into a particular chapter: the best churches, covered bridges, villages, waterfalls, wildflowers, and lakes to photograph as well as the best roads to travel, mountains to drive to the top of, and nonphotography sites to visit. This is all very subjective, of course, so if you disagree with something I've included or are angry with something I've left out, write your own book.

Finally comes My Guide—your chance to co-opt my book and make it yours with my blessings. Use this section to describe new places you find, or review the place you just went to, or write down the address of a person you've met. Notes are important when you get home and can't remember where you were or want to plan for your next trip to Vermont. The more notes you take, the better your subsequent trips will be.

Most importantly, use this book to explore Vermont and enjoy yourself in the process. For such a wee state, there is much to see here, and even more to discover. Grab a map, pick a location, and have a wonderful time. You can thank me later.

How I Photograph Vermont

Whenever I'm photographing, I always evaluate four parameters: the light, the subject, the background, and the conditions. If all four are great—beautiful light, a pretty subject, the appropriate background, and perfect conditions—you have the potential for a great shot. If only a couple of them are great (the typical situation), you are going to have to work a bit harder to get a nice image, and your photographic possibilities will be much reduced.

But having less than the ideal situation to photograph doesn't mean you shouldn't go out and shoot—it just means you're going to have to think about what you're doing. Yes, I know that thinking is the last thing photographers want to do, but you should try it occasionally; it really helps. If you shoot everything on program or automatic, remember: Autofocus, autoexposure, oughtaknowbetter.

Let's examine Vermont's light, subjects, backgrounds, and conditions and see how I can help you get better photographs. By the way, photography is photography whether you're using a drugstore point-and-shoot, an expensive Nikon, or a newfangled digital camera. It's all the process of capturing light in a pleasing way. This is how I photograph Vermont.

Light

Light is the key ingredient for a good photograph. Photography is, after all, the process of capturing light on film. We all think we're out photographing landscapes or barns, or children or flowers or moose, but we're actually out capturing light. If you think about the quality of the light as much as you do the quality of your subject, your pictures will improve dramatically. If you have great light and a mediocre subject, you'll end up with a great photograph, but mediocre light and a great subject will leave you with a mediocre photograph. You have a chance at a great shot only if you have great light—but you'll never get a great shot with dull light. Dull light equals dull photograph. Write that down.

Most of the time I photograph on cloudy days and work in the office on sunny ones. This is because film doesn't like strong light very much; there's just too much of it for the film to completely capture. What happens is that either the highlights are washed-out white or the shadows are blocked-up black. The end result is a very contrasty picture. Slide film and digital film hold the narrowest range of contrast. Print film is better, but no film will faithfully render all the light that's present on a sunny day.

I do occasionally go out and shoot on a sunny day. Blue skies are great for mountaintop photography, for autumn color,

Dull light

and to set off a pretty white church. Blue skies are also great for reflections; I'll often head for water if I'm out and the weather turns sunny. If you know it's going to be a sunny day, go out very early and shoot the first few hours after sunrise. The light at this time is softer and warmer, and everything looks great. The same holds true for later afternoon to sunset.

If you're photographing any buildings with interior lights on, or city- or harborscapes, the best time is twilight. Twilight is the 30 to 40 minutes before sunrise and after sunset. At this time there's just enough light to see the buildings and the scene around them—but no matter the weather, the background will always be a beautiful dark lavender-blue. The interior lights add a nice warm punctuation to the image.

Cloudy days, though, are my favorite time to photograph. The range of contrast is very small when it's cloudy, so all the subtle colors that you see will be captured beautifully by your film. Not all cloudy days are created equal, however. Sometimes it can be heavily cloudy, and other times thinly cloudy. Given my choice, I like thin clouds. On partly sunny/partly cloudy days when the light is varying between full sunlight, heavy cloudy light, and thin cloudy light, I wait until the sun

Good light

is just behind the edge of a cloud to snap my picture. This is the thin light that is rendered best on film.

Cloudy days include rainy days as well. In fact, my all-time favorite light in which to photograph is a light misty rain. Before you start shaking your head, go out and try photographing in this light . . . you'll be wonderfully surprised. You'll have both long exposures and long times to yourself in this light, but it will be worth it, trust me. Some older-generation digital cameras add visual noise to the image with exposures longer than 10 seconds, so beware.

Subject

For everything you photograph, there will be a peak time when it's at its best. It may be a barn after a fresh coat of paint, a wildflower fully in bloom, or an autumn hillside ablaze with color—but everything has a day, a week, a couple of weeks when it's looking great. Ideally, this is the time when you want to photograph it. The problem is that peak times are sometimes hard to find and often last for a frustratingly short period of time.

What to do if you've missed the peak time where you are? If you're too early in spring (or too late in fall), either go farther south or go lower in elevation. You can also try looking for your subject on warmer south-facing hillsides. If you are too late seasonally, go farther north or higher in elevation, or try looking for your subject on north-facing hillsides. The difference seasonally between northern and southern Vermont, and between the valley floors and the mountaintops, can be two to three weeks.

The other problem with trying to pre-

Frosted milkweed pod

always time well spent. The chances are indefinably small that the first whatever-you-find is going to be the best whatever-to-shoot, unless your whatever is exceedingly rare and hard to find. And the best whatever-to-shoot will never be closest to the car, nearest to a comfortable place to sit, or first to be found. One of the definitions of *accomplished photographer* is "one who spends more time looking for something to photograph than actually taking its picture."

Background

Background is usually overlooked despite the fact that it's essential to the overall quality of an image. As photographers, we get so intent on our subject that we forget to consider what's behind it—yet it's the background that will often make or break a picture. I often choose my subject based on the quality of the background, and the angle of the shot is always based on the background. If I'm photographing wildlife, it's the background that determines where I set up and how I approach the animal.

dict peak times is that they're utterly unpredictable. In the years that I've been actively photographing in Vermont, the flowering times for my favorite spring wildflowers and for peak fall color have varied by three weeks. I've found hepatica in full first bloom on April 8 one year and May 1 another year. Peak fall color a few years ago was October 3, and this last year was October 23 where I live. My advice is to stay flexible with your intentions; you'll always find something wonderful to photograph.

The biggest mistake photographers make is to photograph the first something they find without taking the time to look around for perhaps a prettier version or one in a better situation. The question is always: Is this the nicest and best specimen to photograph? If there's one painted trillium in bloom, there will be others—often many others—in bloom nearby as well. If you find one nice section of a stone wall, chances are that other parts in the area may be even nicer.

How do you find out? Put your hands in your pockets or your car in drive and go for a wander. Time spent looking is

Nothing destroys a portrait of an animal, person, flower, or tree like something in the background appearing to come out of the subject's head. The usual culprit is a bright stick or bright piece of grass that intersects the subject and, on film, merges with it. In the three-dimensional world in which the picture was taken, the bright stick was well behind the flower, but in the two-dimensional world of your film that stick is piercing your pretty bloom. I've seen telephone poles coming out of Aunt Edna's head, maple branches as deer antlers, skewered butterflies, and lots of hara-kiri flowers.

It doesn't matter how magnificent your subject is—if the background is terrible, the picture will always be terrible. I diligently look for bright objects in the background. If there's something in your picture brighter than your subject, it will pull attention away from it. Your eye will be drawn to the brightest part of the image, and if that isn't your subject, then it becomes a distraction. Too many distractions and your subject is lost, the image ruined. By the way, one distraction is too many.

How do you know what your background is going to look like before you see the final image? On more sophisticated cameras there is a button you push that allows you to see what the focus of the final image will look like before you take the picture. This is called the depth-of-field preview button. When you push it, the lens closes down to the f-stop you've selected, and you get to see how much of your image will or will not be in focus. In other words, you get to preview your image.

The catch to using your depth-of-field preview button is that your viewfinder gets darker when you do this because you're looking through a smaller hole (your selected aperture); less light is coming to your eye. There are two ways to deal with this annoyance. First, make sure no outside light is hitting your eye. I often cup my hands over my face or use a hat or jacket to keep out any extraneous light. When you do this it allows your eye to adjust to the dimmer light, and your viewfinder will seem brighter. The second trick is to give your eye 30 to 40 seconds to adjust to the viewfinder. If you're in a hurry, though, no matter what you do your eye won't have enough time to adjust and your viewfinder will appear uselessly dark.

In Vermont the biggest background problems are telephone lines, bright reflective metal roofs, raindrops on far leaves, roads, and telephone lines. Did I mention telephone lines? Telephone lines can be very sneaky in Vermont, especially when they sneak through the forest or span a valley, so always be alert for them. If the distraction you detect cannot be judiciously or without harm removed (never, ever break a branch, or pull up a plant, or harm anything just because it's not where you want it to be—your picture, my picture, anybody's picture is really not that important), you can try to darken the distracting background with the shadow of your camera bag, your companion, or even yourself. Use the self-timer on your camera and then move

Bad background

Good background

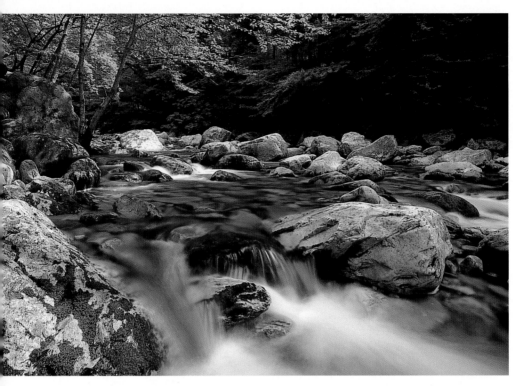

Great light, good subject: Roaring Brook in Arlington

around and cast your shadow behind your subject. I also carry a short length of twine in my camera bag to tie back offending branches without breaking them.

Conditions

Conditions refers mostly to the weather you find yourself in when out photographing, but the term also includes things like your state of mind and the company you're with. Nothing is more frustrating than setting up a pretty shot and then having the wind kick up or the light change right before you shoot. Nothing, perhaps, except trying to photograph with an impatient nonphotographer wondering aloud exactly how long it takes to take a picture. This is usually followed by the equally exasperating comments, "You're taking another shot?" and "Don't you have enough of those?" Might as well pack up your stuff, because you'll never get a good shot under these conditions.

Wind is something you really can't control, so you'll just have to be patient. I have gone through a lot of film doing long exposures when the wind decides to blow halfway through my exposure. Nothing you can do but to try again. On windy days I usually head for streams and concentrate on the moving water and the rocks. Alternatively, try doing long exposures and letting the wind move the colors across your film. Another way to deal with wind is with multiple exposures. Try one exposure in focus and one out of focus. Or try multiple exposures of 16 or 25

shots on a single frame. The duplication will create an interesting depth to your image, and anything moving because of the wind will be hidden under all the layers of exposure.

When I'm out photographing in the rain, I don't use any elaborate rain covers. My camera is about as tolerant of water as I am; when I'm miserable, my camera is miserable. I don't walk around with it exposed to the rain, but when it's on my tripod I don't worry about the little moisture it's collecting, either. I keep a towel in my camera bag and in my car to dry it off eventually, but I don't do any other extraordinary things. Head into the forest when it's raining for your best photography. It won't be raining as hard in there, and the forest will never look better.

My same rule that applies to rain also applies to cold-weather photography: When I'm too cold to photograph, my camera is as well. If it's very cold I carry extra batteries in my pocket to keep them warm, but that's the only precaution I take. Be careful when pushing your tripod into snow—the snow will force the legs even farther apart and may cause them to snap off. Vermont's streams are very photogenic in winter, but beware of the ice that's often hiding under a layer of snow.

If the light has changed, the easiest thing to do is wait. Like just about everywhere else, if you wait 15 minutes here, chances are things will be different. I spend a lot of time waiting for clouds to cooperate with me. Either I'm waiting for a cloud to move on or I'm waiting for a cloud to move in. I once spent two hours waiting for a cloud to clear the top of Mount Abraham so I could get a clear shot of the summit. All the other clouds were moving, but not this one. I never got

the shot. On the other hand, I have also waited many times for a single cloud to float past the sun to soften the light on a summer landscape.

If it turns sunny unexpectedly while I'm out, I usually look for reflections to photograph. Go to a colorful spot like a harbor or a market or a lake and play with the blue sky and the mirror images you find. Blue sky is also a great time for looking-straight-up photographs. Try lying on your back in a forest and shooting the treetops, or lying in a meadow and shooting up at the flowers, or even lying beneath a church steeple and shooting it against the blue sky. Don't lie there too long, though, or they might start a service for you.

The one Vermont condition that you'll never surmount is all our wonderful bugs. The two stars of the bunch are the infamous blackflies and the equally hideous mosquitoes. (Yes, I know, blackflies and mosquitoes are important parts of Vermont's natural history. I would just prefer that they weren't part of my natural history.) Beginning in May and continuing through June—in some high places even into July—blackflies and mosquitoes can become so distracting that they will suck out all your creative juices.

The best way to tolerate them is to learn just to tolerate them. You can try the various salves, sprays, and liquids sold at every country store in the state, but these are only partially effective at best. Be careful to not get any of this goop on your gear, because it can eat away at the plastic. Blackflies are thickest near moving water, and mosquitoes are thickest near still water. That covers just about the entire state. This being said, I have seldom found these two to be so bad that they prevent

me from taking a picture. They can be bad at one location and absent at the next. Just in case, wear long sleeves and long pants, a hat, and an aura of patience. You'll be just fine.

Gadgets and Gizmos

All the typical stuff you normally photograph with is just about all the stuff you're going to need when you're photographing in Vermont. There are a few bits of equipment, though, that I find particularly handy.

Tripod: Every picture in this book and in every book, article, or presentation I've ever done has been taken using a tripod. Yes, I know that they're a pain in the neck to use and yes, I know they can be too heavy and too expensive. It's precisely because they are inconvenient to use that they're so effective. A tripod forces you to slow down and be more deliberate. It allows you to carefully consider your composition, to check the edges of your frame, to look for merges and distractions in the background. A tripod forces you to think about what you do; the more you think about and are involved in the photographic process, the better your images will be.

It's best to spend a little money when you get a tripod; the cheapest ones are impossible to use. A tripod should be infinitely flexible and not fight you every step of the way. Be sure that yours will go flat to the ground or you'll be missing lots of wonderful shots of small critters and plants. Also be sure to get a tripod head (usually sold separately) that's easy to use. This means it allows you to do verticals as easily as it allows you to do horizontals.

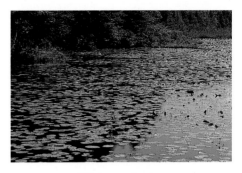

Without polarizer

Polarizing Filter: This filter, when properly rotated, has the ability to darken blue skies and to lessen or even eliminate any glare from flat, shiny surfaces. I almost never use it to darken blue skies—there is an additive effect with a polarizer such that the effect you were going for appears stronger on the film than what you saw in your viewfinder. I do use a polarizer all the time on cloudy and even rainy days, however, to cut the shine from flat surfaces such as leaves and wet rocks. It will increase your exposure by a stop or two, but the enhancement of your image will be worth it. (See above image of Beaver Pond in Wallingford, for example.)

Split Neutral-Density Filter: This is a funny-looking rectangular filter that's half dark gray and half clear. (The dark gray is the neutral-density part; the clear half is the split part.) When held up in front of your lens, it can selectively darken just part of your composition. Split neutral-density filters are usually used when the foreground is in shadow and the background is sunlit. If no filter is used, either the background will look fine and the foreground will be black or the foreground will be fine and the background washed-out white. Placing the gray part

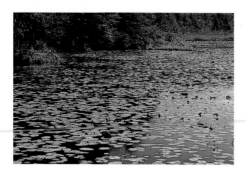

With polarizer

over the sunlit background reduces the range of contrast that the film sees. In so doing, both the foreground and the background will be properly exposed.

Other Filters: Don't schlock up your pictures with gimmicky filters. They're obvious, and their use detracts from the beauty of what you're photographing. If the light or the colors aren't what you want, just wait for a bit until they improve rather than trying to create something that isn't there. Mother Nature doesn't need any help with her sunsets or rainbows or the intensity of her colors. Gimmicks never mean quality.

Diffuser: This is a foldable thin piece of material that softens, or diffuses, harsh light. It is, in essence, a cloud in a bag. A diffuser has rescued many a photo on bright sunny days when the direct sunlight on my subject was much too harsh. (Soft, delicate subjects look best in soft, delicate light.) Most people use a diffuser by just holding it between the subject and the sun. The correct way to use it is to hold it as close to your subject as you possibly can. The diffuser should be just barely outside your viewfinder. When you do this, the light is beautifully soft and wonderful. If the diffuser is even 10 inches farther away, the light turns to dull and is no different in quality than the light of your own shadow. Diffusers come folded up and, when opened, spring to full size. Get the largest one you can conveniently carry.

Lens Hoods: As soon as they get a new lens, this is one piece of equipment that most people discard or put away, never to be found again. Shame on you! A lens hood is essential if you want to photograph in the rain (and you do want to photograph in the rain), because it keeps drops off your lens. Get one that's proper for your lens or else it may catch the edges of your frame and darken your corners.

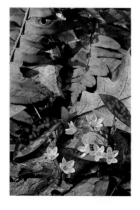

Without diffuser

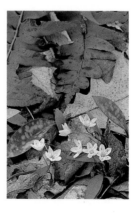

With diffuser

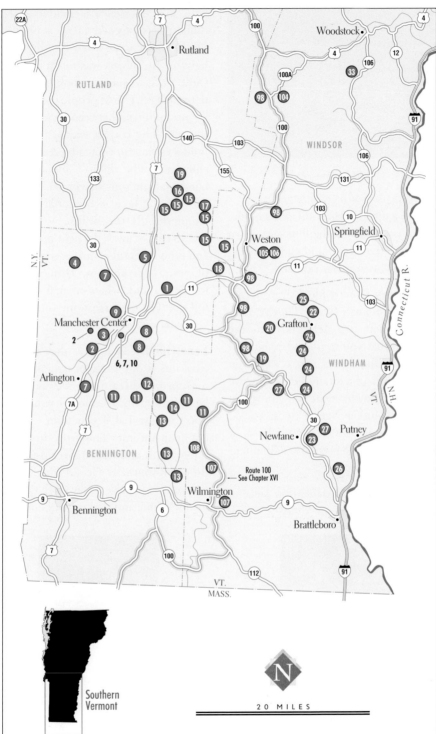

Southern
Vermont

20 MILES

N

Paul Woodward, © 2003 The Countryman Press

Southern Vermont

I. Manchester Center Area

SPRING ★★ SUMMER ★★★ FALL ★★★ WINTER ★★

General Description: Manchester Center sits at the head of the Valley of Vermont and is surrounded by mountains to the west, north, and east. Within a 15-minute drive you'll find beautiful forests and streams and a little jewel of a lake, a pretty waterfall, a road to the top of the area's highest peak—Mount Equinox—and several quintessential New England villages. Additionally, there is the Southern Vermont Arts Center and Hildene, the magnificent home and gardens of Robert Todd Lincoln.

Directions: Manchester is easily found—it's at the junction of Routes 7, 7A, 11, and 30 in southwestern Vermont. If you can't find Manchester, just follow a car with out-of-state plates; you'll get there eventually. Directions to individual sites are included in their specific write-ups.

Specifically: Most people think of Manchester Center as a shopping, skiing, eating, and home-of-the-Orvis-Company kind of place. It's also a great photography center.

Bromley Brook Appalachian Trail/Long Trail Trailhead (1)

Bromley Brook is a pretty little meandering stream in a nice hardwood forest on the west side of Bromley Mountain. At the trailhead the stream, the hiking trail, and a snowmobile trail all intersect, so both the walking and the shooting possibilities are good. Following any of the trails will lead

Where: Southwest Vermont on Routes 7 and 7A
Noted For: Streams, lakes, villages, forest
Best Time: Late May
Exertion: Minimal to moderate hiking
Peak Times: Spring: late May; summer: late June; fall: mid-October; winter: December
Facilities: At developed sites
Parking: In lots
Sleeps and Eats: Many in Manchester
Sites Included: Bromley Brook Appalachian Trail/Long Trail Trailhead (1), Mount Equinox Skyline Drive (2), Equinox Pond and Preserve (3), Merck Forest and Farmland Center (4), Emerald Lake State Park (5), Hildene (6), Dorset, Manchester Village, Peru, and Arlington (7), Lye Brook Falls (8), Prospect Rock Trail (8)

you to many things to shoot: There are lots of wildflowers here in May and June, summer days with low clouds will often drape the forest in enchantment, the leaf-filled curves of the stream are a favorite in fall, and in winter—especially after a new snow—the entire area is a snowy wonderland.

This is one of my favorite sites to photograph the winter forest because the heavy snowmobile use causes the trails to be well packed and easily walked without snowshoes or skis. Go in the midst of a storm or as it's clearing for the best photography. If you're shooting reflections,

get as low to the stream as you can to get the most of them. If you're interested in a bit of exertion, it's not a bad walk to the top of Bromley Mountain with its views from the ski trail meadows. The dirt road from the lot leads east to a small pond and a couple of houses—but this is private property, so be respectful.

Be careful leaving the parking lot, because the traffic goes very fast here and visibility is limited. Do not ever park on Route 11/30. In winter the lot is plowed but can be very icy, as can the plank snowmobile bridge. Be sure to lock your car and to hide anything valuable here; trailheads are notorious spots for thievery and general mischief.

Directions: The trailhead parking lot is on the north side of Route 11/30, 0.5 mile west of the Route 11/Route 30 intersection near the Bromley Mountain ski area. Or take exit 4 off Route 7 in Manchester Center and head 4.2 miles east on Route 11/30.

Mount Equinox Skyline Drive (2)

Mount Equinox is the high peak that dominates the northern part of the Valley of Vermont, and, quite wonderfully for photographers, a 5-mile-long road (small fee) goes all the way to the top. The 3,000-foot elevation gain means that the top is at least a couple of weeks behind the valley floor in spring. If you can't find wildflowers down low, you'll be able to find them up top. If the autumn color isn't yet peak down low, it will be high on Equinox, and when there's a cold rain in the valley you'll find a heavy frost on the summit.

A web of trails surrounds the summit. The best one for photographers is the 0.2-mile-long path that goes to Lookout Rock on the north side of the summit ridge. This trail starts behind the currently defunct Summit House and leads easily to this small but impressive lookout. I think the best views are from the knife-edge, a narrow section of the toll road near the summit. If you look south at sunset with a long lens, the ridges stack up into a nice composition.

The other spot I stop at is the picnic area about halfway up the toll road. The large sugar maples there are very pretty in June and in September through October. You can step back and shoot from across the road, or you can walk underneath the old giants and shoot up into beautiful crowns. Pick a blue-sky day to shoot up to prevent distracting white-sky leaks.

The road is very steep, so be careful when you're descending to preserve your

View from Mount Equinox

Kim Grant

Equinox Inn

brakes. You can hike up Mount Equinox if you like, but it's a consistently steep trail. The popular Burr and Burton Trail starts at the Burr and Burton Academy, which is behind the Equinox Inn in Manchester Village. I have found the owners of the toll road very friendly; if given proper warning, they'll try to accommodate your early or late gate requests. The road is closed by November and opens again in May.

Directions: The entrance to Skyline Drive is 3.9 miles south of the Equinox Inn on Route 7A. It's well signed and difficult to miss.

Equinox Pond and Preserve (3)

Equinox Pond is a scenic little spot nestled into the low, forested slopes of Mount Equinox. The entire area surrounding the pond is part of a privately held preserve, but it's open for walking, running, or hiking and is the closest good nature-photography spot to downtown Manchester Center. The entire preserve is extremely well signed; there are connecting trails to the top of Mount Equinox and to the Southern Vermont Arts Center's spring wildflower trail.

The preserve is best from late April to

mid-May for wildflowers and for the first couple of weeks in October for fall color. If you happen to be around on a foggy, lightly raining summer day or after a fresh snowfall, the trails can be enchanting then as well. The woods around the pond are a bit bedraggled, but if you walk any of the trails you'll come to nicer forest shortly.

Directions: From the north side of the Equinox Inn, follow Seminary Road west toward Mount Equinox. Seminary Road curves south and turns into Prospect Road. The parking area is at the beginning of Equinox Pond Road, 0.7 mile from the inn. There is space enough here for only a few cars. It's easier to park behind the inn and walk from there. You can get a nice map of the trails and additional information inside the inn.

Merck Forest and Farmland Center (4)

The Merck Forest is a private foundation that owns a beautiful hunk of land west of Manchester and runs environmental education programs for the public. The surrounding land is a magnificent mix of mature hardwoods, farm fields, rocky lookouts, and old woods roads. The center is open all year and can be good for photography anytime. Late April to early May will be the peak of the spring wildflowers; mid-October is the peak of fall color, but anytime is good if the conditions are right.

The forest is laced with a network of trails and well signed. My favorites are an old town road that wanders beautifully through the forest, the 5-mile round-trip trail to the top of Mount Antone—where there are magnificent views—and the 3-mile round-trip trail to the top of Spruce

Peak, which also has great views. This is a place where you could spend hours or days photographing—I plan to spend years visiting it. There are a total of 28 miles of trails here. Take your time and explore them all.

In addition to the trails and the hilly landscapes there are always interesting seasonal programs offered. A small visitors center and classroom building is the best place to start and get oriented.

Directions: Follow Route 30 for 1.8 miles west out of Dorset to the intersection of Route 315. Turn left and go 2.4 miles to the top of the big hill. The Merck Forest and Farmland Center entrance road is on your left at the top of the hill. The visitors center is 0.5 mile down this road.

Emerald Lake State Park (5)

Emerald Lake is a pretty little lake with steep, forested sides squeezed tightly between two mountain ranges. This small state park is best known to locals for its summer swimming beach, but there's much for photographers here as well. Most of the lakeshore is undeveloped, so reflections and forest edge shots are al-

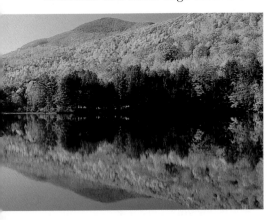

Emerald Lake State Park

ways worth investigating. There are trails that lead off into the mature hardwood forest here, as well as one that leads steeply up to a natural rock bridge. A state natural area encompasses the shrubby marsh to the south of the lake. The lake is close to and easily visible from Route 7.

I pass this lake twice a day and stop often to explore its shore. The light and conditions are usually different here in this little pocket than in Manchester—it's often foggy or frosty around the lake only, and it may be cloudy here when it's sunny in town. Whatever the weather, it's always worthwhile to check out Emerald Lake.

The best access point is from the paved pullout on Route 7 just south of the entrance road. This is where most fishermen park, and it provides easy access to the east side of the lake. Reflections are best in the morning when the west slope of the lake is illuminated and the east side is still in shadow. There is no nice afternoon light here because the mountains block the sun completely. Access to the trails is gained from the entrance road. A small fee is charged to enter the park.

Directions: Emerald Lake State Park is 3.7 miles north of the Routes 7 and 7A merger in East Dorset and 4.5 miles south of Danby. The entrance is on the north side of the lake.

The roadside pullout is 0.1 mile south of the entrance road. From the pullout, scramble down to the railroad tracks and then follow the informal fishing trails to the lake. I have found the best photography to be a bit south of where I park.

Hildene (6)

This is the longtime home of Robert Todd Lincoln, Abraham Lincoln's oldest

son. Robert built this 24-room Georgian Revival home in 1902 and lived here until his death in 1926. In 1978 a local group dedicated to restoring it to its original grandeur bought the estate. The house and the grounds are now open to the public.

Hildene is a magnificent building set on equally magnificent grounds that include pretty woods and beautiful formal gardens. There is much here to keep a photographer happy. You'll find wildflowers in the woods in spring and early summer, roses and peonies among many other flowers in the gardens in summer and fall, grand architecture and a forest alive with color in fall. Hildene is also open in winter and is especially pretty after a fresh snowfall.

Directions: Hildene is 0.6 mile south of the Equinox Inn on Route 7A. There is a small fee for tours of the house but not to explore the grounds.

Villages: Dorset, Manchester Village, Peru, and Arlington (7)

If you want to photograph or even just wallow in classic New England scenery, these four villages are for you. Each has wonderful old homes and inns with big front porches, white picket fences, overflowing gardens, and big old sugar maples in the yards. Manchester Village and Dorset are particularly dripping in quaint. Arlington is close behind.

Drive the back roads in Arlington, Manchester Village, and Dorset for more wonderful old New England architecture. (Manchester Village is the old part of Manchester Center. Go to the Equinox Inn—that's Manchester Village.) In Dorset and Peru there are also great country

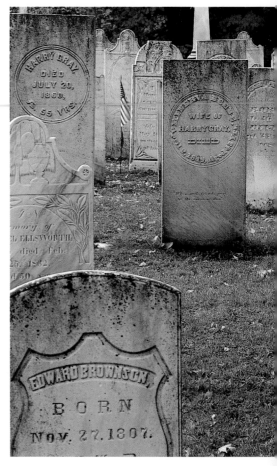

Cemetery in Arlington

general stores to explore and photograph. Peru has a fair in September that's a gas to wander and look for images.

In Arlington there is a very scenic old cemetery next to the old church in the center of the village. The Battenkill River flows through the northwest corner of the village, then west in a lovely valley that's also traced by Route 313. The very photogenic, bright red **West Arlington covered bridge** (best shot in the morning) is down this road as well. Climb up the bank on the north side of the road for the best vantage.

Remember, though, that these are private homes and stores, not a national park display, so be polite and considerate of everybody's privacy. Still, it has been my experience that if asked, most folks will be delighted to let you take a few pictures and may even show you more to photograph around back. To repay their kindness, be sure to get their address and to send them a picture you took there when you get home.

Directions: Dorset is a few miles west of Manchester Center on Route 30. Arlington is a few miles south of Manchester Center on historic Route 7A. Peru is a few miles east of the Bromley ski area on Route 11, less than 10 miles east of Manchester Center. Manchester Village is the old south-side part of Manchester Center and is centered on the grand old Equinox Inn.

Trails: Lye Brook Falls and Prospect Rock (8)

These two very scenic hikes require a bit of exertion, but both are short and offer lots for the curious photographer. On rainy days there's much to photograph trailside, so don't get discouraged if it's wet outside.

Lye Brook Falls is one of Vermont's most published waterfalls, but because it isn't a roadside attraction you'll probably be the only photographer there. It's a tall, tumbling thin veil of water clasped in a wooded glen. At the base of the falls a perfectly placed boulder makes for a great foreground subject.

If you want to photograph the falls with the most water, go in late May when the leaves have come out in the surrounding forest. To photograph them at their most colorful, go after a day or two of rain in early to mid-October when the forest is ablaze with reds, oranges, and yellows. Don't go at anytime in the middle of a drought because there will be too little water coming over the falls.

Lye Brook Falls is not the only thing to photograph on this hike. At any time of year the forest on the way to the cascade can be magnificent. Because this hike is higher in elevation than the valley floor, things will be a bit later to come out here in spring and a bit earlier to become colorful in fall. Look for spring wildflowers along the trail in May and woodland streams in summer.

Directions: From exit 4 off Route 7, go uphill on Route 11/30 for 0.2 mile to East Manchester Road. Turn right here and continue for 1.1 miles to Glen Road on your left just before the underpass. Follow Glen Road straight ahead for 0.4 mile to its dead end and the trailhead. Follow the trail for 1.8 miles to the signed spur trail on your right. The falls are 0.4 mile down this trail.

Prospect Rock is a rocky lookout perched on top of the high ridge that defines the eastern wall of the Manchester Valley. From the rock, the Valley of Vermont and all of Manchester are laid out below you, with Mount Equinox looming on the far side. With views mostly to the west, this is a good morning hike and a great hike for a family.

This hike is a favorite of locals because it's close, short, and ends with magnificent views. Again, this reward requires a bit of exertion, mostly in the first part of the hike, but not too much. Prospect Rock is on the Appalachian/Long Trail (AT/LT), so more ambitious hikers can

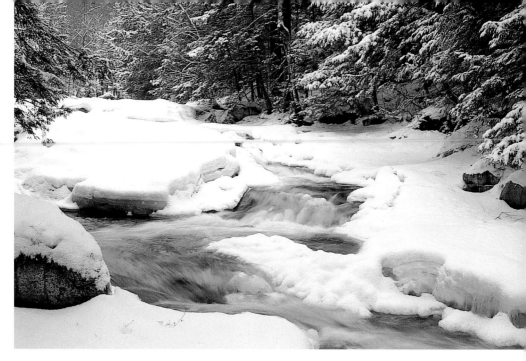

Roaring Brook in winter

portunities for a curious photographer. I once saw a moose, orchids, beavers, and ospreys all on the same day here. This is also one of the few worthwhile sunrise locations in Vermont. In winter the road to Grout Pond is never passable from the Arlington side, but you can usually follow it from West Wardsboro.

A few miles east of Grout Pond Road, you'll reach the original hamlet of Stratton. Don't confuse this tiny crossroads with the mega resort of the same name that lies on the far side of the mountain to the north. If you want to head back west, turn left here onto West Jamaica Road and follow it through the Stratton Mountain ski area development to Route 30 in Winhall. To avoid the ski area, continue straight on Kelly Stand Road (here called the Arlington–Stratton Road) for 4 miles to its intersection with Route 100 in West Wardsboro.

Recommendations: The first couple of miles of the western Kelly Stand Road is sparsely populated. This is the only part of the road open year-round on the west side. My favorite section to photograph starts at the large parking lot (a bit beyond the last house) and continues for the next few miles. In May there are lots of wildflowers along this part of the road, especially red and painted trilliums.

If you miss the wildflowers in early May, they will be out in later May and June farther and higher up the road. Grout Pond is almost 2,000 feet higher in elevation than the lower brook, so things can be a month later up there. Don't give up if you can't find what you're looking for down low along the stream.

In summer you can choose to hike, canoe, or linger waterside and be absolutely content no matter what you decide. The water is much lower in summer, so new

Spring beauty, Danby

river compositions are always a possibility. If you want to get away from the road, you can explore the high ponds or take a hike along one of the several crossing trails. The AT/LT is a popular summer destination, as are the trails to Stratton Pond and Branch Pond. Branch Pond is about 100 yards from the end of the road; you can walk the canoeing access trail or take the longer hiking trail to the far side of the pond and beyond.

You just can't go wrong anywhere along this route in autumn. If it's too green where you are, go higher; if it's too brown, go lower. The best color is generally in very early October at Grout Pond and in mid-October along the lower stream—but I've seen the peak vary by two weeks in the six years that I've been paying attention. Even if you arrive a bit

late, there's still much to photograph. Look for downed leaves in quiet pools or frosty details along the stream edge.

In winter you'll have the entire stream to yourself, unless I'm there. The road is closed past the big parking lot (it's used by snowmobilers at this time of year) after the first big snow, but there's plenty to shoot along the first couple of miles of the stream. You can walk up the road from the parking lot as well; just be careful of speedy, not-completely-in-control snowmobiles. Even if there isn't much snow on the ground, there are often layers upon layers of ice built up on the rocks in the stream, which are wonderfully photogenic.

Pro Tips: I can't think of a reason not to use a polarizer when photographing the stream. Turn it until you see the glare disappear from the water. I inevitably use a wide-angle lens when shooting the stream. Look for a good foreground and cut out the sky for your best results. If you're here on a sunny day, concentrate on smaller details to avoid as much contrast as you can. If you're here on a windy day in June, consider yourself lucky, because the bugs can drive you to distraction on still days in early summer. Long sleeves and bug dope are always a good idea here.

Cautions: There is a small footbridge to a private cabin along the lower part of the stream that can sometimes sneak into a picture. The distant road or a bridge is easy to overlook, so keep a lookout if you don't want them in your image. Campsites along the shore of Branch Pond and Grout Pond are also notorious for getting into your shot. The footing near the stream at any time of the year can be

tricky—slippery when wet in spring and summer, and icy when cold in winter. Wet leaves and ice under snow are particularly dangerous. If you park alongside the road, be aware that it's sometimes used in winter by logging trucks that don't like using their brakes with a heavy load—and really don't like cars in their way—so be very careful where you park.

Diversions: Kelly Stand Road is a great spot for bird-watching because the elevation difference causes lots of habitat diversity. Again, you can always go for a walk or a short hike if your mind's not on photography. In June and July there are lots of through-hikers along the LT/AT who are always good for a few stories.

Arlington, along Route 7A (follow Kansas Road west), is a pretty village with classic New England scenes to capture. This is Norman Rockwell country, so there's a nice museum in town and a pretty **covered bridge** near where he once lived (ask locally for directions). If you like to fish, Roaring Brook empties into the Battenkill River a little north of Arlington. The Battenkill is a blue-ribbon trout stream; when you lie about what you didn't catch, lie big.

Nearby: Jamaica State Park is on Route 30 a few miles past Stratton Mountain ski area. The Mount Equinox toll road is between Arlington and Manchester Center. Somerset Road (FS 71) and the Somerset Reservoir are worth exploring and, combined with this route, make a good all-day photography circuit.

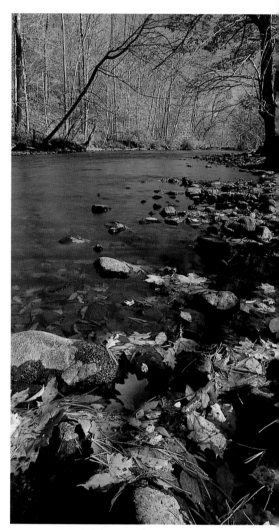

Battenkill River

III. Mount Tabor–Weston Road

SPRING ★★ **SUMMER** ★★★ **FALL** ★★★★ **WINTER** ★

General Description: The **Mount Tabor-Weston Road (FS 10) (15)** travels, as you might expect, between Mount Tabor and Weston in the central part of the Green Mountains. A three-season road, it's a favorite of mine because it passes through great forests, crosses many pretty streams, and takes you past wildflower meadows, nice views of the Green Mountains, and a beaver pond.

> **Where:** Between Danby and Weston
> **Noted For:** Mountain streams and forests
> **Best Time:** Mid-October
> **Exertion:** Minimal to moderate
> **Peak Times:** Spring: mid-April; summer: late June; fall: mid-October; winter: road closed
> **Facilities:** Few
> **Parking:** Roadside or lots
> **Sleeps and Eats:** Manchester or Rutland

Directions: From Route 7 in Danby, turn east at Crosby's Lumber (stop in and say hi to Elby). The road (marked as FS 10) is paved as it climbs the mountain but then turns to gravel. It comes to a T-intersection after 13 miles. Turn left here onto Little Michigan Road; turn left again after 0.4 mile onto the Landgrove–Weston Road to get to Weston, or right to get to Landgrove and Peru. In Weston ask locally for directions to find the tricky eastern end of this road.

Specifically: There is much to photograph along this road. I travel it many times a year and find new things to shoot every trip. One of my favorite places is where the **Appalachian Trail/Long Trail (AT/LT)** and **Little Black Brook (16)** cross FS 10. Both the stream and the woods are very pretty, especially upstream along the trail. I love the shot from the little bridge looking upstream at the arching beech tree.

A number of smaller forest service roads come off FS 10, and each is worth exploring. The longest is FS 30, 6.4 miles from Route 7, which heads down to the Big Branch River and the old logging camp of Old Job. This is the easiest access to the river and worth a look. At times of low water it's possible to cross the river and continue exploring to the south. Very few people actually do this, so it'll be all yours to wander.

The crest of the road, called **Devils Den (17),** is reached at 7.7 miles. On either side of the Den are pretty views, stream, and mature forests. In the afternoon this is a good area to look for glowing, backlit forest detail shots.

A beaver pond is reached at 9.2 miles. This pond can either be full and worth lingering at or drained and pretty dull. I have seen moose here, and regularly find snapping turtles exploring the pond edges. Past the beaver pond, Utley Brook begins to follow the road and offers more things to explore. On the opposite side of the road from the brook is the boundary of the Big Branch Wilderness, so those with a wandering heart will find ample room to explore.

The Mount Tabor–Weston Road ends at Little Michigan Road in **Landgrove (18).** Turn left and then left again onto the

Landgrove–Weston Road, where you'll find a nice farm with beautiful draft horses. The owners have always been very friendly to me—and their horses have as well. The adult horses will come up to the fence to say hi; in summer there are often young drafts around, too. Landgrove, to your right at the intersection, is another pretty little mountain hamlet that's nice to explore. The area is full of horses, stone walls, and tree-lined roads.

Recommendations: Most of the photography along this route is roadside: You see something that catches your eye, you pull over to the side of the road, and you get out and take a picture or 12. When you're finished, wander up and down the road a bit and you'll find more things to photograph. I always drive this road both directions because I'll see things going one way that I didn't see the other.

The highest parts of this route are often in the clouds when the valleys are in the sun—and conversely, it's sometimes possible to climb out of the murk in the valleys and get above it all on this road. If it's raining, head for the forest and you'll be very happy.

Spring flowers occur a week or so later, and fall color can be a week earlier along this road; plan accordingly. If you've missed fall color or gotten stuck with a mediocre year, the beech trees here turn a golden-bronze color very late and in some years provide the best color. I have shot wonderful colorful images along this road as late as the fourth week in October.

Pro Tips: If you walk a little way upstream on the AT/LT along Little Black Brook, you'll typically find quiet pools that are perfect for reflections and floating leaf shots. Try using an extra-long exposure to let the slowly moving leaves paint across your image. Digital shooters have the advantage doing this because they can preview what can't be seen with the naked eye and decide whether to keep it or not.

Don't bypass exploring the back roads of Landgrove and Peru, the next township to the southwest of Landgrove. This means wandering around and getting lost, but it will likely lead to terrific discoveries.

The road is closed in winter after the first snow—but there's no gate, so as soon as the snow melts it's possible to head up. I love driving here in late May when the wildflowers are out along the roadside and the first new leaves are coming out in the forest. The paved section of the road is perfect for into-the-canopy pictures because it traverses a steep slope and puts you at treetop level.

Trails: The AT/LT from the Black Brook crossing going north is a mostly level walk that leads to a very pretty boreal lake, **Little Rock Pond (19).** It's one of my favorite easy ambles. From the very first parking lot that you encounter, 2.5 miles from Route 7, there's a trail that descends steeply to the Big Branch River. I've never hiked this trail because of the consider-

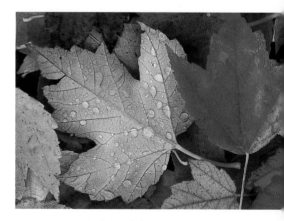

Red maple leaves

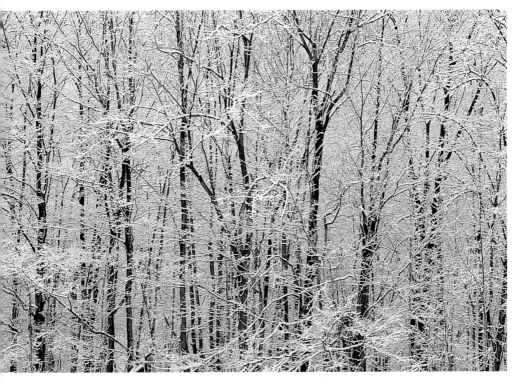

After the storm, Danby

able effort involved, but I bet it sure is pretty down there.

The first half of this road is in the southern part of the White Rocks National Recreation Area, but most of the trails and sights to see are in the northern part. A trail that leads north from Devils Den links up with the White Rocks to the north.

Cautions: If you choose to drive this route before it has been officially graded and readied for the season, you're likely to find trees and limbs across the road and very soft shoulders. If you get stuck, you'll have a very pretty but very long walk out. In Landgrove, Peru, and Weston most of the land is private property, so be respectful of residents' privacy. If you just ask permission, you're likely to get more pictures than you thought.

Diversions: FS 10 is a great, if energetic, mountain bike road. If you like antiques, Danby and Weston have plenty of shops to keep you busy. In September the Peru Country Fair is lots of fun, as are the crafts and antiques shows in Weston. Weston also has an active summer theater if you're craving a break from your own company.

Nearby: There is much to photograph in the Weston area and north and south on Route 100. See chapter 16.

IV. Jamaica State Park

SPRING ★★★ SUMMER ★★★ FALL ★★★★ WINTER ★★★

General Description: Jamaica State Park (19) includes several miles of the West River where it curves through steep, forested mountainsides. A wide, level trail, a former railroad bed, follows the river for 3 miles. **Hamilton Falls (20),** the tallest in the state, is part of this river valley as well.

Directions: In the village of Jamaica, turn north at the white Community Church in the center of town, cross a bridge, pass a small school, and cross a second bridge. Immediately past the second bridge, the entrance road to the park is on your left. To reach Hamilton Falls, drive north on Windham Hill Road from West Townshend, then turn west onto West Windham Road. The trail to the falls starts at the end of this road.

Specifically: In every season there is much to photograph at this park. Depending on the water level, you can either walk along the riverside looking for compositions or walk the trail and then cut down to the river wherever you wish. Don't ignore the forest, though, because there are pretty wildflowers in spring and summer, mossy boulders and ferns in summer, and lots of mushrooms and bright leaves in fall.

On a cloudy day you can photograph here all day long. The long exposures will cause the water to appear silky and add a nice artistic element to your image. If there's any sun, arrive in the morning and work the reflections from the sunlit far side of the river on the still-shaded near-side waters.

Where: Off Route 30 in Jamaica
Noted For: Wide, accessible river in forest
Best Time: Mid-October
Exertion: Minimal to moderate
Peak Times: Spring: mid-May; summer: June; fall: mid-October; winter: January
Facilities: In park
Parking: In lots
Sleeps and Eats: Townshend and Newfane

I prefer a rainy day here—or at least a cloudy one, so there isn't too much contrast. In fall, when the river is low and there's a mist in the air, you'll think you've died and gone to photography heaven.

In winter the park is open, but the road is not maintained; you may have to walk the 0.5 mile to the trailhead. If you can get here after a fresh snowfall, you'll be in the middle of a winter wonderland and may never want to leave. Again, walk the river's edge and shot after shot will unfold in front of you.

Hamilton Falls is difficult to photograph, and the rocks around it are very dangerous. The hike from the river is a steep 1-mile-long trail. The hike from the top is shorter, but the perspective from up there is not as pleasing. I always get sidetracked by the passing riverscapes when heading to the falls and so have missed the best conditions there.

Recommendations: Spring wildflowers will be best in mid-May, when painted and red trilliums, clintonia, pink lady's slippers, and trout lilies will be blooming

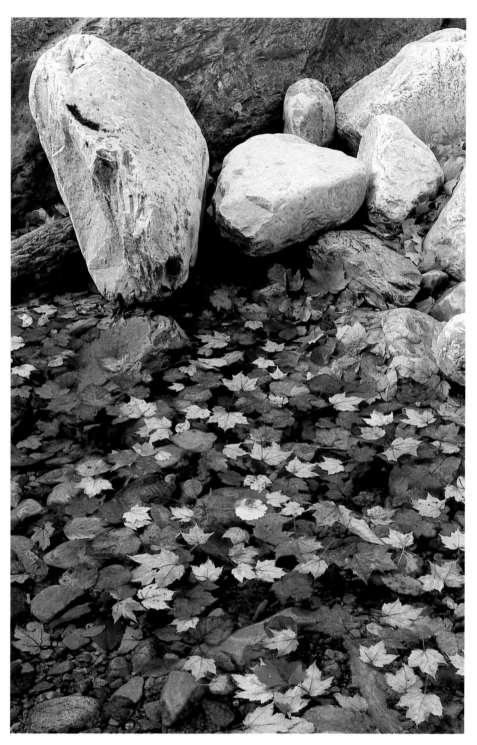

Maple leaves in river pool, Jamaica

in the forest. You'll find different flowers in the hemlock forest than you will in the hardwoods, so look in both places.

Riverside wildflowers bloom in summer to early fall and make beautiful foregrounds for your river shots. This is a popular fishing and kayaking river, so rather than being frustrated that there's someone in your picture, use the person for a point of reference in your compositions.

Anyplace in the park is great in fall and winter, especially when something is falling out of the sky. Remember, when it's raining or snowing it's always drier in the forest than out in the open, so wander the trail if it's too wet and wait for a break in the weather to go down to the river. Don't get stuck in one place; make yourself walk farther.

Pro Tips: I try to walk along the river and look for plants, pools, or boulders to use as foregrounds for my compositions. When the water is low in late summer and into fall, you can easily wade out into the river and get pictures that are very exciting. When I can pry my eyes off the sweep of the river, I'll often find wonderful smaller compositions in the woods and along the edges of the river.

There is a cluster of large boulders about a mile down the trail that is always photogenic no matter the depth of the water. When you're ready to turn around and head back, leave enough time to continue to photograph. You'll see things differently heading back, and if you allow yourself you'll find even more compositions.

River rocks look much more colorful and interesting when they're wet—another good reason to photograph in the rain or just afterward. Use a polarizer for any pictures that include leaves, water, or wet rocks: It will remove the glare and let the richness of the rock show.

Cautions: Wet rocks and leaves are slippery, so step carefully. In winter the trail can be very icy even if there's a coating of snow on top. Skiers and walkers use it heavily, so it should be relatively packed down. Still, taking a step closer just to get a slightly better view of Hamilton Falls may cause a serious fall. It's not worth it.

Diversions: The towns of **Jamaica, Townshend,** and **Newfane** all feature classic New England architecture and Vermont friendliness. You can find a bite to eat, an inn for the night, and more antiques than you can shake a firkin at. They all deserve time spent exploring. If you're a runner or an exercise walker, there's no better place to build up a sweat than the trail here. And if you really want a slice of Vermont, an auction is held most Saturday mornings just south of Townshend. The quality of the local characters is often better than the quality of the items to be sold.

Nearby: The chairlift at **Stratton Mountain ski area** runs during summer and fall to take tourists to the top of the mountain. This makes for a nice downhill hike or mountain bike option and gives you a good look at the surrounding countryside. If you like pretty Vermont villages, Grafton, to the east, is one of the prettiest, and Black Mountain is farther down Route 30 (see chapter 5 for both).

V. Grafton–Newfane Area

SPRING ★★★ SUMMER ★★★ FALL ★★★ WINTER ★★

General Description: This area of southeastern Vermont has a little bit of everything—quaint villages, rural landscapes, beaver ponds, mountain lookouts, covered bridges, and maple-lined back roads. The highlights are **Grafton (22)** and **Newfane (23),** two of the prettiest villages in all New England, and **Black Mountain (26),** an easy walk to a great view through a forest of pitch pines and mountain laurel.

> **Where:** Off Route 30 in Jamaica
> **Noted For:** Wide, accessible river in forest
> **Best Time:** Mid-October
> **Exertion:** Minimal to moderate
> **Peak Times:** Spring: mid-May; summer: June; fall: mid-October; winter: January
> **Facilities:** In park
> **Parking:** In lots
> **Sleeps and Eats:** Townshend and Newfane

Directions: Grafton is at the intersection of Routes 121 and 35 west of Bellows Falls. Townshend and Newfane are on Route 30 due south of Grafton. To get to Putney Mountain Trailhead parking, turn east off Route 30 onto Grassy Brook Road (0.9 mile north of West Dummerston) and follow it to Putney Mountain Road. At the top of the hill you'll find a small but well-signed parking lot on your left.

To get to Black Mountain, turn off Route 30 just north of West Dummerston and cross the river on the West Dummerston covered bridge. Continue uphill on Eastwest Road for 1.5 miles to the top of the hill and turn right onto Black Mountain Road. The trailhead parking lot is 1.1 miles ahead on your right.

Specifically: Grafton (22) looks like a living quaint museum with beautiful old houses, shady lanes, and sheep grazing on the town green. Incredibly, all the power and telephone lines have been buried in the center of the village so you won't have to worry about those annoying distractions in your pictures. Behind the Grafton Cheese Shop (very, very good cheese) is the Kidder Hill Covered Bridge. There are several town walking paths that lead to wonderful back-street scenes and old stone walls, barns, pastures, and ponds.

Newfane (23) is renowned for its village green ringed by fine old buildings and a cluster of three beautiful white churches. Any of the side streets here will lead to new picture discoveries. Townshend is also pretty with a very picturesque church in the center of town. All three of these villages are Norman Rockwell kind of places, so no matter your mood, park your car and go for a wander.

The best rural scenery is to be found on the **Grafton–Townshend Road (24),** which runs due south out of Grafton, on Route 121 close to Grafton, and on the southern end of Grassy Brook Road below Putney Mountain. You can find more rural landscapes on South Wardsboro Road between Newfane and Route 100, and on East Dover Road, which runs between Routes 30 and 100 and goes through the towns of East Dover, South Newfane, and Williamsville.

Within all this peopled landscape are some great sections of forest. The best is along **Route 121 (25)** west of Grafton. Route 121 looks a lot like a country gravel road that was named by someone with a wry sense of humor, so don't think you're on the wrong route just because the road doesn't live up to its highfalutin name. The surrounding forest will meet your expectations, though.

Black Mountain (26) has very nice—and very unusual—Vermont forests. The start of the trail passes through mature pines and hardwoods, but it changes to an interesting scrub oak, pitch pine, and mountain laurel forest on top. I'm not sure any other place in Vermont features this later forest type. For photographers this means a completely new set of wildflowers and animals, plus new textures and shapes and patterns with which to play.

The other nice sections of forest are in Hedgehog Gulf along Athens Road (the northern extension of Grassy Brook Road) and up Putney Mountain Road. Two large beaver ponds in Hedgehog Gulf along the road are worth exploring.

Recommendations: Park your car in Grafton and just start walking around; you'll find much to photograph. Then get in your car and drive the nearby back roads. This should keep you happily occupied for most of a day. Now go do the same in Newfane and Townshend. If you decide to actually talk to any of the residents around here, you may find yourself overly content, so be cautious about being too friendly.

Wildflower season is late April through May—earlier in the valleys and later on top of Putney Mountain and Black Mountain. The mountain laurel blooms in June and should not be missed if you're in the area.

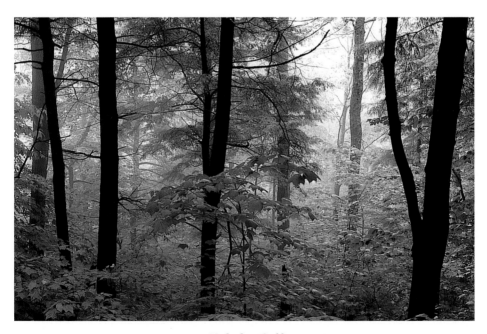

Hedgehog Gulf

Putney Mountain

Anytime in summer will be productive. Work the back roads looking for quintessential Vermont scenes and linger by swimming holes, general store porches, and lemonade stands. Again, beware of lurking happiness.

Pick any spot around here in fall and you'll find photos galore. During all October there will be things to photograph. Prime time for foliage should be in the middle of the month, but there will be some color from mid-September until late October.

One of my favorite things to do after a fresh snowfall is drive around this area and look for Currier & Ives picture to take. New snow will cover up many sins, and if

you arrive before the wind starts to blow there will be lots of it on bough and bale.

Pro Tips: If you are photographing buildings, stand a little way away from them and use a longer lens. This avoids the distortion in the image that occurs when you stand too close and use a wide-angle lens. Also, try shooting at twilight when there's still enough light to see the entire building, but not enough to make out much of the background. Wait until the lights come on and you'll get magical and inviting pictures.

If it's windy, photograph subjects that don't blow around, such as old houses and barns. Concentrate on their details as well as the big picture. If it's rainy, head for the forest where it won't be as wet. On a blue-sky day, wander up Black Mountain early or late to capture the best light, or play with water in the streams, lakes, and ponds of the area.

Trails: It's about a 20-minute amble to the top of Black Mountain, I think, but I can't say for sure because I've never walked it without stopping to take a picture. **Putney Mountain (27)** is an even easier walk that takes you out to an open mountain meadow. In fall there is an active hawk count here that tallies the raptors migrating south.

Two more strenuous trails (but not very strenuous) start across the Townshend Lake Dam. One goes up to the top of **Bald Mountain (27)** and the other, the Ledges Trail, loops around some rocky overlooks above the lake. Both would be good on any nice day for photography.

Cautions: Always ask permission when you're photographing private property. It has been my experience that when asked,

people are very friendly and accommodating—and my pictures are better for it. Be sure to send them a print of the picture you took as a way of thanking them and making it easier for the photographers who follow you. If you decide not to ask, on the other hand, you won't get as nice a shot, and you may get a talking-to.

Also, remember that people working are actually working, and chances are they have a lot to do. They may look like they have been put there just to improve your picture, but I'm guessing they have other ideas. So don't get in their way and don't be too annoying. We treat most tourists like innocent children, but occasionally one needs to be disciplined. Don't let it be you.

Diversions: Let's see, you can look for antiques, buy cheese and other artisan foods, go for a walk, hike, bike, ride, canoe, raft, hayride or run, go bird-watching or swimming, or just eat an ice cream cone on a village green. If none of these things appeals to you, go home!

Nearby: Jamaica State Park is west up Route 30. Mount Snow with all its seasonal recreational offerings is in West Dover over on Route 100. The Saxtons River is also very photogenic between Grafton and the town of Saxtons River. The granddaddy of New England rivers, the Connecticut, isn't far to the east. Most of it is developed, but you can find pockets of riparian forest and pretty farmland. The mouth of the West River, where it meets the Connecticut, has been set aside as a bit of a nature preserve and is a nice place to look for aquatic birds and scenes.

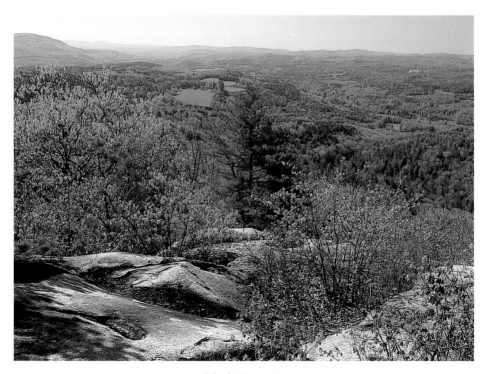

Black Mountain

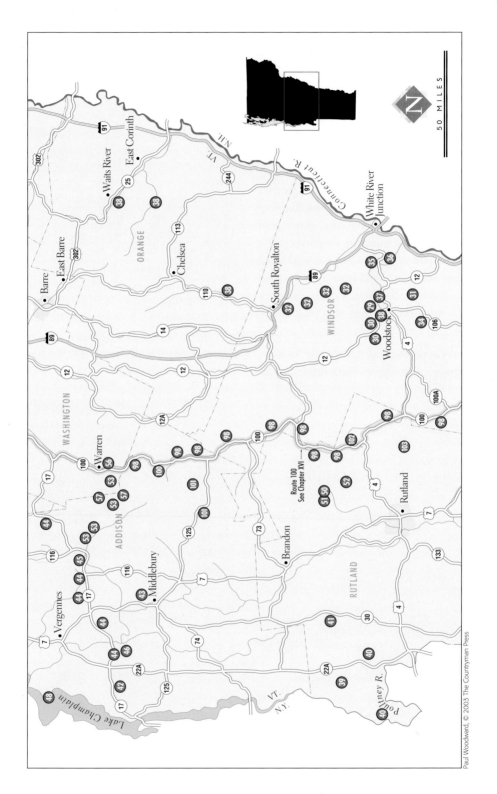

50 MILES

Paul Woodward, © 2003 The Countryman Press

VI. Woodstock Area

SPRING ★ ★ ★ **SUMMER** ★ ★ ★ **FALL** ★ ★ ★ **WINTER** ★ ★ ★

General Description: Woodstock combines the best of Vermont into a very small, neat, and beautifully wrapped package. Everything is classic New England: old buildings and beautifully restored homes, pastoral landscapes (including the most photographed farm in America), a bog with blooming orchids, a meandering river with covered bridges, and Vermont's only national park property. All this plus an outstanding nature center with many live birds of prey on display.

Directions: Woodstock is easily found: Just follow Route 4 west from exit 1 off I-89 or east past Killington from Rutland. Woodstock is also at the junction of Route 12 from the north and Route 106 from the south. Directions to individual sites are included in their specific write-ups.

Specifically: Woodstock is, in my humble opinion, the prettiest town in New England in one of the prettiest settings. It's an ideal spot for one-camera couples because there's much to keep the non-photographer happily occupied.

Where: Eastern Vermont on Route 4
Noted For: Classic Vermont village and landscape
Best Time: Mid-October
Exertion: Minimal to easy hiking
Peak Times: Spring: May; summer: June; fall: mid-October; winter: December
Facilities: At developed sites
Parking: In lots
Sleeps and Eats: Many in Woodstock
Sites Included: Woodstock Village (28), Billings Farm and Museum (29), Marsh-Billings-Rockefeller National Historic Park (Mount Tom) (30), Eshqua Bog Natural Area (31), Cloudland Road (32), Jenne Farm (33), South Woodstock (34), Vermont Institute of Natural Science (35), Quechee Gorge (36), Gillingham's General Store (37), Villages of Tunbridge, Corinth, Chelsea, and Waits River (38)

Woodstock Village (28)

Woodstock proper is more or less centered on the village green, the narrow ellipse of lawn in front of the grand Woodstock Inn. Through the center of the town runs the Ottauquechee River (you figure it out). The most photogenic homes in town are on the north side of the river along River Road and Mountain Avenue and around Elm (Route 12) and Pleasant Streets. You will find beautiful, stately homes with white picket fences, cute gardens shaded by old sugar maples, and inviting front porches.

As much as this looks like a movie set, there are actually people who live in these homes, so please respect their privacy. If you see a picture that you like (how could you not?), be sure to ask permission before you grab your camera. You'll find that homeowners are very friendly and often

Woodstock street scene

flattered when asked for permission to take a picture or two. And chances are that you'll be allowed better access if you ask, and may be shown shots that you couldn't have seen otherwise.

Across the green on the north side is a pretty **covered bridge** that makes a nice shot. The sugar maple that frames it on the green side is especially effective in your composition in October, when it's in full autumnal color.

Billings Farm and Museum (29)

This magnificent property, tucked into a wide bend of the Ottauquechee River, is both a working dairy farm and a living farm museum. In the pretty rail-fenced pastures you'll see flocks of sheep, herds of cows, gaggles of geese, and draft horses the size of locomotives. All are used to people and very well taken care of, so pic-

ture taking is relatively easy. There is also a restored 1890 farmhouse and lots of period outbuildings and pieces of farm equipment.

A nice visitors center, shared with the national historic park, should be your first stop. A small fee is charged to wander the farm. There are demonstrations, classes, and tours offered daily during the tourist season; the staff are easily found to answer questions. This is a great place for a family to visit.

Directions: From the east end of the village green, turn left (north) onto Elm Street (also Route 12), cross the iron bridge, and follow the road around the curve to the site. The shared parking lot with the national historic park is on your right. Turn right onto River Road and immediately right again into the lot; the visitors center is at the head of the lot. It's

about a six-minute walk from the village green to the Billings Farm.

Marsh-Billings-Rockefeller National Historical Park (30)

This park isn't much bigger than its name, but there's an awful lot to see and photograph. Named for three leading conservationists who owned this property in succession, the park is a 550-acre wooded area on **Mount Tom,** the little mountain that shelters Woodstock to the north. The park is laced with hiking trails and carriage paths with multiple points of access, making exploring it very easy. The town of Woodstock's Billings Park actually includes the twin summits of Mount Tom, but the rest of the mountain and the surrounding woods are all within the national historic park. Locals consider it all one area.

Within the forest are small meadows and a pretty little pond called the Pogue that's an easy walk from the parking lot. On the way you'll pass the Marsh-Billings-Rockefeller carriage barn and mansion, both stately and impressively restored. Tours are given of the house, and you're free to wander around the lawn and gardens and other buildings. If pressed, I could live here.

Once you get past the buildings, start walking on any one of the carriage roads. The main carriage road, which leads into the heart of the park and then circles the Pogue, peels off to the right shortly after you cross Route 12. You can also access the park from a trailhead on Prosper Road on the park's west side, from the old trails of the Mount Tom ski area on its north side, from behind the cemetery on River Street, and from the trails of Faulkner Park on Mountain Avenue.

When in doubt, turn north and walk uphill. You'll bump into a path soon enough.

There are woodland wildflowers in spring, meadow flowers in summer, and glorious colors in fall. In the green months I usually head for the Pogue and see what's happening there, looking for reflections, floating leaves, or early-morning mist rising from the waters. The trails are open in winter, and the area is very pretty after a fresh snowfall. The best views of Woodstock are from the South Peak Overlook of Mount Tom directly above Faulkner Park and the village green. The entire park is within easy walking distance of Woodstock.

Directions: From the east end of the village green, turn north onto Elm Street (also Route 12), cross the iron bridge, and follow the road around the curve to the site. To get to the shared parking lot with the Billings Farm and Museum, turn right onto River Road and immediately right again into the lot. The main visitors center is at the head of the lot. The Marsh-Billings-Rockefeller National Historic Park is across Route 12, where there's another visitors center.

Eshqua Bog Natural Area (31)

This little bog is owned by The Nature Conservancy and, in-season, contains stunningly beautiful bog wildflowers. You'll initially be surprised when you see it, because you'll think there isn't much here to see, let alone photograph—and at some times of the year that's true. But if you come in May for woodland wildflowers, June for bog orchids, or October for fall color, you just might be stunned.

The great thing about Eshqua Bog is

that there's a boardwalk running through the center that provides easy access and a good platform from which to photograph in this quaky environment. Don't go off the boardwalk: Bogs are fragile, and you'll end up killing something no matter how careful you are. Pink lady's slippers bloom in early June, yellow lady's slippers in mid-June, and the prize of them all, showy lady's slippers, in the third week of June.

There are orchid lovers and lots of locals who visit the bog, so you'll have to share the narrow boardwalk. Be patient and wait for them to move on to ensure a still tripod; it's worth it. I only go on rainy days when there are fewer people around and the flowers are bejeweled in raindrops. You might be carried away by the bugs in May and June—but then again you might not be.

Directions: At the 90-degree turn on Route 4 east of town (at the Maplefields Convenience Store), instead of following Route 4, go straight up the hill on Hartland Hill Road. Bear right onto Gavin Hill Road and go about a mile to a small pullout on your right. The trail starts behind the sign where there are sometimes trail booklets.

Showy lady's slippers

Cloudland Road (32)

You'll wonder about this road at first, but then you'll thank me as soon as you start driving it—there are more postcard shots along Cloudland and its various continuations than you can shake a Maplefields doughnut at. You'll find pretty barns, spreading maples, stone walls, rolling hills, and beautiful countryside to photograph. The AT also crosses the road if you want to hike a bit.

Cloudland Road ends at the little town of Pomfret. From here you are surrounded by even more landscapes of old Vermont—old barns, old maples, old walls, old men, and shy sheep. This is wandering territory. You can turn east onto the Kings Highway toward West Hartford, or north toward East Barnard, or west toward Barnard. The more you get lost, the better the pictures you'll find.

Again, remember that this is all private land. Almost everyone has learned to be tolerant of the odd tourist, but don't push your luck. Strike up a conversation before you set up your camera and your pictures will be better.

Directions: From the Billings Farm and Museum parking lot, continue east on River Road for 0.8 mile to the left turn onto Cloudland Road. Pomfret is about 5 miles up this road; Barnard is on Route 12.

Jenne Farm (33)

It's said that this is the most photographed farm in America—and probably the entire world. There are times in fall when there will actually be a traffic jam on the narrow dirt road leading to the farm; buses even stop for the Great Unwashed to step out and snap a quick

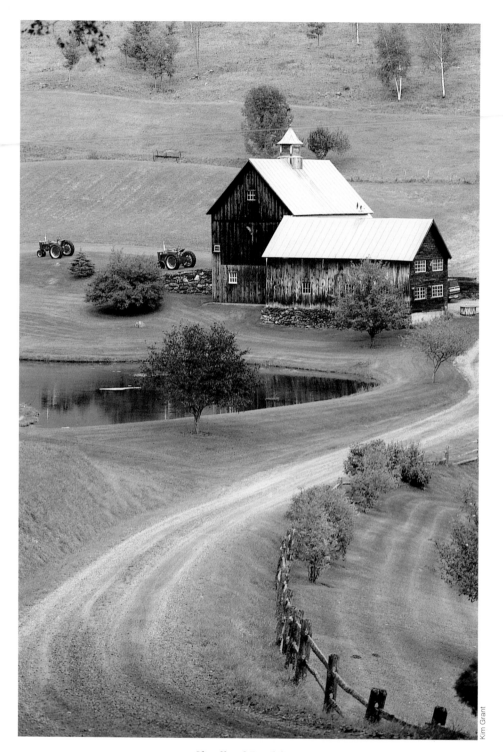

Cloudland Road farm

picture. (If you're reading this, you automatically are not part of the of Great Unwashed.)

Despite all this, the farm is certainly worthy of all the photographic attention. Even though it has been photographed thousands of times, it's only a cliché if you don't have the shot. As soon as you have the shot, it becomes a favorite.

The first thing you need to do is pronounce the name correctly: *jen-nee,* like the girl's name. The second thing you need to do is come in the morning, because there's really nothing to photograph in the afternoon on a sunny day. You can photograph any time of day if it's raining or snowing or the wind is blowing the drifts around.

The best shot is where you first see the farm, well away from the red farm buildings and house. Use a longer lens to crop

Old maple, South Woodstock

out the sky but not so long that it cuts out the surrounding fields. The road makes a nice foreground, as does the big old maple that conveniently grows where any photographer would plant it. Don't start prowling around too close to the buildings, though. The Jennes are very hospitable and extremely gracious to put up with all the nonsense associated with living in a postcard, but don't ruin it for future visitors. I understand all the Jennes are excellent shots.

On the way to the Jenne Farm you will go through **South Woodstock (34),** another spectacularly beautiful New England village. There's a great general store in town and a pretty white church up on a hill. If this town reminds you of holiday beer commercials with horse-drawn sleighs, you watch too much TV.

Directions: To get to the Jenne Farm, take Route 106 south from Woodstock for 8.1 miles and turn right onto Jenne Road. The view of the Jenne Farm is 0.25 mile up this road. The turn onto Jenne Road comes just after you reach a height-of-land on Route 106. The start of Jenne Road is very steep; be careful and prepared at this dangerous intersection.

Vermont Institute of Natural Science (35): VINS is an environmental center that's well known for its captive and rehab birds of prey. The birds are in very nice outdoor cages, and visitors can get quite close to them. On weekends there are often volunteers with birds on their arms sharing their natural history. VINS has a brand-new building and is a great source of nature information.

Directions: VINS is in the process of moving to a new facility along Route 4 in

with a very slow shutter speed so that the birds all blur together.

Cautions: Don't try to be clever and circumnavigate the rules in order to get closer to the geese. You'll end up spooking the birds, not getting your shot, and getting in trouble. Brilyea Road can be muddy in spring and difficult to travel with a normal car—but it's nothing that boots and a walk can't solve. The rest of the year, the road is rutted in places but fine.

Diversions: You can always go for a walk or go bird-watching. Canoeing is great here as well. Head north on Dead Creek for the longest possible paddle. Dead Creek joins Otter Creek a few miles north of the refuge and soon flows into Lake Champlain. There are a number of low dams along the way, but nothing too difficult.

The pretty college town of **Middlebury (43)** is always a nice place to wander, with lots of shops, galleries, and interesting places to eat. Middlebury College, in the middle of Middlebury, has a beautiful campus. The old chapel on the hill is worth several pictures. Vergennes is also a favorite place of mine to grab a bite or simply stretch my legs.

Nearby: Route 17 (44) east from Addison is one of my favorite roads to travel in Vermont. The route travels a wonderful cross section of the state as you go from the lakeshore through farmlands with pretty little villages, up over Appalachian Gap, and then down to Route 100 in Irasville. The western section from Addison to Bristol passes through lovely farmland. Stop in **Bristol (45),** a "Doc Hollywood" town, for a big piece of pie

Americana. If you like main streets with waving flags and strolling families, Bristol is the place for you.

Snake Mountain (46) has a not-too-difficult mile-long trail to the top, where you'll find a stunning view of the lake, the farmland, and the Adirondack peaks across the lake. The trailhead is off Wilmarth Road, 2.9 miles south of Addison. Snake Mountain also has very nice wildflowers in April. Hunting season is in November, so be careful in the woods then.

Marsh marigold

IX. Mount Philo and Champlain Parks

SPRING ★★★ SUMMER ★★★ FALL ★★★ WINTER ★

General Description: Mount Philo (47) is a little nubbin of a mountain with a good road to the top that has an outsized view of the Champlain Valley and the looming Adirondack Mountains. Button Bay and Kingsland Bay State Parks are small points of land in the lake; both also have magnificent views of the water and mountains beyond.

Directions: Mount Philo is off Route 7 about halfway between Shelburne and Vergennes. Turn east onto State Park Road and follow it briefly to the entrance. Button Bay State Park is due west of Vergennes, and Kingsland Bay State Park is north of Vergennes where Sand Road and Hawkings Road meet.

> **Where:** Between Vergennes and Shelburne off Route 7
> **Noted For:** Champlain views
> **Best Time:** Summer
> **Exertion:** Minimal
> **Peak Times:** Spring: April; summer: June–July; fall: October; winter: December
> **Facilities:** Yes
> **Parking:** In lots
> **Sleeps and Eats:** Vergennes or Shelburne

Specifically: Mount Philo doesn't look like much from Route 7—in fact, you'll probably think you're in the wrong place—but don't let its unassuming appearance fool you. From the top, the views of the nearby farmland, the lake, and the distant mountains of New York are spectacular. This is one of the most photographed and most published views in Vermont.

The road makes a loop around the top, following the edge of the summit cliffs and lookouts. The first lookouts (the southernmost) are best for views south and southwest, while the farther lookouts (the northernmost) are best for views to the northwest and north. Views east toward the Green Mountains are obscured.

The best time to take pictures is either midmorning or very late in the afternoon into sunset. You want sunny weather and blue skies because the sky will be an important part of your composition. There isn't much close foreground, so don't kill yourself trying to add something that's not going to enhance your picture.

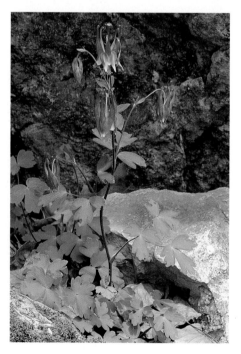

Red columbine

XI. Lincoln Gap Road and Area

SPRING ★★★ SUMMER ★★★★ FALL ★★★★ WINTER ★★

General Description: Lincoln Gap Road (53) is the back way over the Green Mountains between the towns of Bristol on the west side and Warren and Route 100 on the east. This is one of the highest road gaps in Vermont (2,410 feet), so there is a boreal feel to the forest here. Large boulders, twisted old trees, and mossy little scenes abound. The Long Trail (LT) crosses at the gap, and there's plenty of space for parking. This road is closed in winter.

Directions: Lincoln Gap Road intersects Route 17 just on the far side of the bridge over the New Haven River a few miles east of Bristol. On the east side, Lincoln

Where: Northeast of Middlebury	
Noted For: Wildflowers, forest, and views	
Best Time: Late May	
Exertion: Easy walking to moderate hiking	
Peak Times: Spring: May; summer: June; fall: early October; winter: January	
Facilities: None	
Parking: Roadside and in lots	
Sleeps and Eats: Middlebury	

Gap Road turns west off Route 100 on the south side of the town of Warren.

Specifically: On the west side of the gap, the first 5.5 miles of **Lincoln Gap Road (53)** follows the New Haven River through rolling hills and small villages. Parts of the river are very photogenic, and there's a nice waterfall 0.2 mile up the road from the Route 17 bridge. The little village of **Lincoln (54)** is reached 3.3 miles up the road. There are views of the mountains if you go north here. Take Quaker Street to Downingville Road and then wander northward up the back roads for more photographic opportunities.

I come to **Lincoln Gap** most often in late May and June looking for wildflowers I missed at lower elevations. Trout lilies, trilliums, violets, starflower, twinflower, wood anemone, goldenthread, and clintonia are some of the common flowers you'll find here. The forest on either side of the gap, accessible by the LT, is wonderful with hemlocks and spruces punctuated by twisted birches and maples. A shelter on the south side of the summit sleeps eight if you want to be in position to photograph the sunrise or sunset.

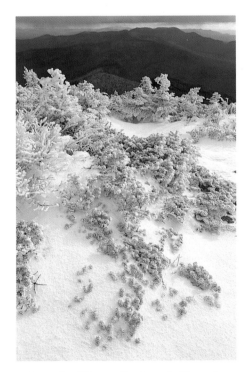

Summit of Mount Abraham in November

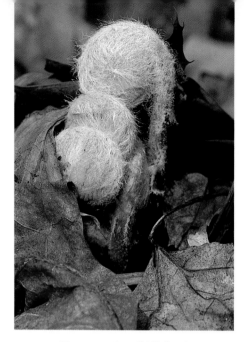

Cinnamon fern fiddleheads

covered bridge (56). There's a natural stone bridge in the stream through which it's possible to photograph the bridge. Ask locally for access to the stream.

Pro Tips: The road to **South Lincoln (55)** turns off the main road 4.3 miles from the bridge. You'll find views of Mount Abraham and access to more forest, including the Breadloaf Wilderness Area. If you want to continue following the New Haven River upstream, turn onto Big Basin Road in South Lincoln. For more exploring, the Lincoln–Ripton Road also cuts south through the forest from South Lincoln, eventually intersecting Route 125, Middlebury Gap Road. This is a very little-used road, so you're unlikely to see another photographer here.

On the west side, where the road begins to steepen and climb to the gap, it passes through a nice lush part of the forest. I've had good luck with wildflowers here in May and through summer. I'll also come down here if it's too windy for photography at the gap or along the LT.

If you have the energy to get to the top, don't let your exhilaration cause you to forget about good photographic composition. The stunted little spruces and firs around the summit make for great foregrounds and subjects in themselves. Use a wide-angle lens and tilt the camera down to emphasize the foreground. You'll love the results.

Trails (57): From the gap it's a relatively easy hike to the top of Mount Abraham—the beginning of an 11-mile ridge walk, known as the Monroe Skyline, that stretches between Lincoln Gap and Appalachian Gap. The entire trail is photogenic, but especially the summit, which is rocky and has 360-degree views. It

Fall is obviously the most magnificent time to explore Lincoln Gap. Even if you notice that the gap is in the clouds, go on up and photograph the colors of the forest in the fog. It can storm and snow early this high up, so you may find that many leaves have fallen. That's okay; just take pictures of fallen leaves.

In winter the road is closed about a mile from the gap, but there are still good views to be had of the snowcapped mountains. The best views are from the open meadows past the turn to South Lincoln. There are also views in winter from Downingville Road.

The east side of the gap is mostly forested, but it's certainly pretty. There are some open old meadows with aging stone walls to photograph, as well as a number of dirt roads that lead off into the forest. When you get to Route 100, turn north toward Warren and take the side street into town to find the attractive **Warren**

takes me a little less than two hours to reach the top without too many stops.

If you don't have the time or inclination for this much of a hike, you can walk south on the LT to **Sunset Ledges** and pretty views west over the Lincoln Valley, Lake Champlain, and the Adirondack Mountains. The trail is steep in a few spots, but the lookout is stunning. Expect to take about 45 minutes to reach the ledges.

There's a marked trail to what is supposed to be a view a short way downhill from the gap on the west side. This trail leads through some nice woods, but I've never found a view worthy of its own walkway. This is not to say that I haven't taken some nice pictures here—they just haven't been of a view. If the LT is too crowded to concentrate on your photography, this trail won't be.

Cautions: The road near the gap can be suddenly icy in early spring or anytime in fall, so try to pay attention to your driving when you're cruising for shots. This also applies to the rocks of the summit. On the summit, try to walk only on the bedrock to protect the extremely delicate summit vegetation.

The weather at the gap will be different from—very likely windier and colder than—down in the valley. This applies double to the summit. Only go to the gap if your vehicle and clothing are suitable, and only go to the summit if the weather is nice and you have a few extra layers just in case.

If you want to photograph the frosty white summit of Mount Abraham in wintertime, be sure to wait for a blue-sky day or at least for a time when there is blue sky behind the white mountaintop. If you don't, the summit will merge with the white clouds and disappear on your film.

Diversions: Continuing on Route 17 will take you over **Appalachian Gap (58)** and then down past the Mad River Glen ski area and the pretty village of Waitsfield. There is a small mountain lake almost at the summit of Appalachian Gap that always looks productive for pictures but has yet to yield any to me. I always stop, though, and look around. Route 17 is open year-round; if you don't mind some arctic conditions it can get pretty wild and astonishingly beautiful here in winter after a storm.

Nearby: There is a picturesque white church in **Starksboro,** farther north on Route 116. If you continue north and don't follow Route 17 over Appalachian Gap, you'll soon come to Huntington and then the **Green Mountain Audubon Nature Center (59).** There are nice people here who may be able to help you find things to photograph, along with some very pretty trails through their property. It's always worth a stop to at least pick their brains and stuff a couple of dollars into their contribution box.

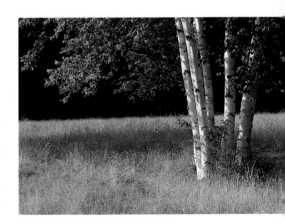

Birches near Lincoln

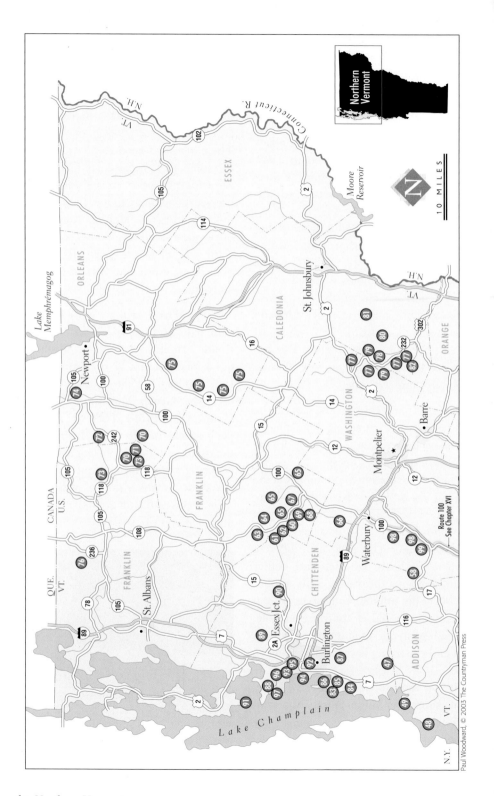

XII. Stowe Area

SPRING ★ ★ SUMMER ★ ★ ★ ★ FALL ★ ★ ★ WINTER ★ ★ ★

General Description: Stowe is a little village on the Waterbury River tucked between the imposing mountains of Mount Mansfield, Vermont's highest, to the west and the Worcester Range to the east. There's a good road to the summit tundra of Mount Mansfield; nearby are waterfalls, narrow notches, and magnificent mountain views.

Directions: Take exit 10, Waterbury, off I-89 and go north on Route 100. When the traffic slows down, you'll be in Stowe. Route 108 goes west from the center of the village toward the ski area and then over Smugglers Notch to Jeffersonville on Route 15. Directions to individual sites will be given in their write-ups.

Specifically: No matter the season, no matter the month, there's always something to photograph in the Stowe area. There are winter scenics, maple-sugaring barns, spring wildflowers, summer views on Mansfield's summit, and glorious fall colors everywhere.

Where: On Route 100 north of I-89
Noted For: Mountains, falls, and a pretty village
Best Time: June
Exertion: Mostly minimal to some hiking
Peak Times: Spring: late May; summer: June; fall: early October; winter: December
Facilities: At developed sites
Parking: In lots
Sleeps and Eats: Many in Stowe
Sites Included: Mount Mansfield Toll Road (60), Tundra Trail (61), Stowe Ski Area Gondola (62), Smugglers Notch (63), Sterling Pond (64), Bingham Falls (65), Sterling Falls (65), Moss Glen Falls (65), Little River State Park (66), Wiessner Woods (67), Trapp Family Lodge (68), Stowe Bike Path (69), Ben & Jerry's World Headquarters

Mount Mansfield Toll Road (60) and Tundra Trail (61)

This is a very well-maintained gravel road that climbs the south shoulder of the Stowe ski area and stops at tree line just below the summit ridge. Most of the road passes through rich northern woods as it climbs into the uppermost spruce and fir forest. Don't speed past the lower part: In-season you'll find woodland streams and summer wildflowers on the winter ski trails. There's a pretty chapel in the woods 1.6 miles from the start of the road.

The main attraction is, of course, the top of the mountain. The road stops at a large lot tucked into the stunted little trees at tree line. Just above the lot a short walk leads to the summit house, where shelter from the wind and chill can be found and interpretive exhibits explain the delicate tundra environment of the summit ridge. During the summer tourist season, volunteers from the Green Mountain Club and

the University of Vermont give guidance and help you protect the area.

From the parking lot the Long Trail (LT) leads north through the spruces and firs to the open, rocky summit 1.4 miles away. It's a relatively easy and mostly level 40-minute walk with just a little elevation gain at the very end. If you aren't feeling up to the full walk, the first good view is from Frenchman's Pile, 10 minutes from the lot. If it's blowing a tad, an alternate trail through the trees also goes to the top and is a bit more protected.

Photographers are going to be drawn to the grand scenic, especially when three states and two countries are laid out in front of them, but don't forget to notice what you're walking past. In June there are magnificent little tundra wildflowers tucked into crevices in the rocks and growing in the lee of boulders. There are also wind-sculpted trees and great slabs of rocks to include in your compositions.

Never, ever walk on the tundra vegetation of the top, but rather step from bedrock to bedrock. One wrong step can cause many years of damage and even destroy what you came up here to celebrate. The summit ridge is 90 percent exposed granite, so it really isn't much of a hardship to stay on the rocks.

The road is open from when the snow melts in June until mid-October. The special tundra flowers bloom in early summer; the woodland wildflowers along the toll road bloom in early May down low and late May up high. Fall color on the summit ridge arrives in mid-September and in the woods below from early to mid-October.

The toll road opens at 9 or 10 AM and closes at 5 PM, but if you want to get up there earlier it wouldn't hurt to ask. If you want to do sunset photography, you'll have to walk down. It takes about an hour (without stops) to walk down, and at least a couple of hours to get up via the road. At the tollhouse at the beginning of the road you can get a guide to the route and the trails of the area. A fee is charged to use the road.

It's possible to get to the summit ridge by riding the **Stowe Ski Area Gondola (62),** but the lift doesn't go all the way to the very top: From there it's a hellacious 0.7-mile scramble straight up on the Cliff Trail. Note that the Cliff Trail is considered harder than the Profanity Trail, which also ends at the summit. That should tell you something. The spruce-fir forest at the top of the gondola is worth exploring for summer wildflowers and mossy-ferny little intimate landscapes.

Directions: The entrance to the toll road is a bit hidden by all the ski area development, but if you look carefully you'll see the sign. The entrance to the toll road is 5.8 miles uphill from the center of Stowe and 1.7 miles downhill from the ski area. Look for the more obvious sign for the Inn at the Mountain and turn there.

Smugglers Notch (63)

Smugglers Notch is the high point on Route 108 as it slips over the northern shoulder of Mount Mansfield. The area isn't very big but it *is* very interesting, squeezed between high cliffs, sprinkled with huge boulders, and traced by a narrow but perfectly passable (mostly) road. The trees, cliffs, rocks, flowers, and road are so close here that you can hardly walk anywhere around the notch without tripping over a composition.

The notch itself is so narrow that the

Arctic wildflowers on the summit of Mount Mansfield

Smuggler's Notch

road through it is only one lane; still, there are numerous pullouts and places to park. The one-lane section isn't very long, but the road is steep enough that this section is closed in winter. At this time it's a popular destination for cross-country skiers and snowshoers and should not be overlooked on a nice winter day for photographers.

This is a popular spot where casual sightseers, bird-watchers, wildflower enthusiasts, walkers, day hikers, and through-hikers on the LT all come together. This sometimes makes roadside photography problematic, but if you go in the morning or wander away from the road you'll likely have the woods to yourself. The south-side cliffs of the notch are closed in midsummer because they comprise a peregrine falcon nesting area.

I especially like playing with the huge boulders in the forest. Interesting subjects in themselves, they also make interesting backdrops for forest scenes. There are also ferns growing against the rocks and twisted old trees growing around the rocks. In the boulder fields at the base of the cliffs where it's colder in the damp shadows are wildflowers not commonly found in Vermont, including butterwort, purple mountain saxifrage, marble sandwort, and pale painted cap.

A nice hike that goes from the notch to **Sterling Pond (64)** is cut into the north slope of Spruce Peak. It's about a mile upward to this popular destination, but it's a scenic little pond and worth the effort. From the pond you can walk back toward the top of Spruce Peak or continue on the LT northward.

Directions: Follow Route 108 northwest from Stowe or southeast from Jeffersonville. In winter the road stops just past the Stowe ski area on the east and just past the Smuggler's Notch ski area on the west side of the mountain.

The Waterfalls of Stowe (65)

There are three very scenic waterfalls in the Stowe area, all easy to walk to. The forest around each of them is also photogenic. The falls look best in late May and June and then after a good rain in October. In early winter these sites are very pretty with a little ice and fresh snow.

Bingham Falls: This is a bounding series of falls in a hemlock-lined gorge. As of this writing there are no formal trails to the falls, but lots of informal paths lead you through the forest and along the edge of the various cascades. Be sure to wander both up- and downstream to get the best

shots. And don't be satisfied with just one composition: There are lots to be found here.

Directions: Parking for the falls is at an informal, but large, pullout 0.5 mile uphill from the entrance to the toll road on your right. A wide trail leads diagonally downhill to the edge of the upper falls.

Sterling Falls: This waterfall is part of the small Sterling Falls Gorge Natural Area but is surrounded by a couple of thousand acres of protected forest. Within this natural area are three waterfalls and a number of smaller cascades and pools. The falls are in a very narrow hemlock chasm that is as much a grotto as it is a gorge. A trail follows closely the top side of the gorge, but getting a clear shot of any of the falls can be difficult.

I prefer photographing waterfalls from below, but even so this area is so darn pretty that I come back to it repeatedly. The roads leading up to the gorge have photography potential as well. The lower roads pass through nice farmlands and have good views of the Worcester Range and Mount Mansfield. The roads closer to the falls pass through mature forests that are also rich in things to photograph. Look for wildflowers in spring, forest patterns in summer, and terrific color in fall.

Directions: From the center of Stowe, go 0.8 mile on Route 100 to West Hill Road on your left. Follow this road until you eventually come to Sterling Valley Road. Turn left and follow it to the end, where you'll find the trail down to the gorge.

Moss Glen Falls: This is the second Moss Glen Falls; the first is on Route 100 in Granville. Apparently there are only so many names for waterfalls in Vermont, so

we had to start going through the list again. Like Sterling Falls, this one goes through a gorge in a series of drops, but unlike Sterling the trail takes you to the base.

From the parking area, a short trail leads through a meadow and then into the woods along a tributary of the Waterbury River. The base of the lower falls is first encountered, but you can follow the trail to the upper falls if you wish. At times of low water you can wade across the river and get closer to the falls.

Directions: From the center of Stowe, go north on Route 100 for 3 miles to Randolph Road. Turn right and then quickly right again onto Moss Glen Falls Road. This road ends at the parking area for the falls.

Bingham Falls

Little River State Park (66)

This state park is on the southern end of the Waterbury Reservoir south of Stowe. What's different about it is its strong historic component. While there are the typical forest pictures to take, you'll also get many shots of old homesteads, woods

roads, and other pieces of the old settlements that once were here.

A number of trails here are worth exploring. The Stevenson Brook Trail is in two parts: The upper part follows the bank of Stevenson Brook upstream, while the lower part is a formal nature trail that leads downhill to the reservoir. Paralleling the upper Stevenson Brook Trail are the Daily Loop Trail and the Hedgehog Hill Trail. Along these trails are lots of stone walls, a couple of cemeteries, an old schoolhouse, and a number of cabins and cellar holes of former cabins.

Directions: Little River Road intersects Route 2 at a spot 1.4 miles west of Waterbury. Turn to the north here; the state park is at the end of this road.

In the Village: Wiessner Woods (67), Trapp Family Lodge (68), Stowe Recreational Path (69)

These three areas are also worth exploring if you're stuck in the village without a ride. **Wiessner Woods (67)** is a small forest preserve with marked trails just past the Edson Hill Manor on Edson Hill Road. Typical forest photography opportunities can be found here. Try it in winter after a fresh snowfall. Even if you don't feel like taking pictures, it's the best place for a quiet walk close to town.

The **Trapp Family Lodge (68)** of *Sound of Music* fame is on Trapp Hill Road off Route 108. This is a renowned lodge that has always had a strong outdoor slant. There are thousands of acres of rolling forests with many miles of trails worth exploring. In spring there is an active maple-sugaring operation here, and the public is welcome to watch or participate. In winter this is one of Vermont's premier cross-country skiing centers. The sweeping views of Mount Hunger and Mount Worcester are extraordinary.

The **Stowe Recreational Path (69)** is a 5-mile bike path from the village to the ski area roughly paralleling Route 108. While some of it is developed, there are parts that go through meadows and by the side of the river. A side loop trail where only foot traffic is allowed is my favorite part of the trail. The trail starts behind the Community Church in town.

Recommendations: If you're here in May, spend your time at the waterfalls and the surrounding woods unless it's a bright sunny day. Waterfalls are too contrasty in the bright sun. Just about any woods with larger trees (mature woods) will have a nice assortment of wildflowers to enjoy.

In June go up the mountain in the morning or late afternoon. In July and August work the spruce-fir forest high on Mount Mansfield and look for flowers and little forest scenes. At this time of the year the waterfalls are running pretty low unless there's a big downpour during your visit. You can also ride the gondola and walk down a ski trail looking for meadow flowers on the way.

Close-up of Smuggler's Notch forest

In autumn go anywhere you want at any time, especially if you catch a cloudy day. If it's a rainy day during October, count your lucky stars: Every picture you take will be great. In winter I like to linger around town, especially at twilight when the indoor lights add a nice golden highlight to my pictures. The Trapp Family Lodge is a must in winter. You may start singing at the top of your lungs, but it'll still be worth it.

Fall aster, Stowe Recreational Path

Pro Tips: When I'm up on the summit ridge, I'm either looking for little scenes to photograph (especially if it's windy) or seeking out foregrounds for my sweeping landscapes. I use a wide-angle lens to emphasize the foreground and give some depth to these compositions.

Use a polarizing filter for your shots of waterfalls. Not only will it take the glare off the water and allow the true colors to come through, but it will also slow down your shutter speed by one or two stops, giving the water a soft, angel-hair appearance.

If you're in the village and the clouds appear low, go to the beginning of the toll road and ask the folks there if the summit is above the clouds. Then scoot up, take your shots from the top, and work the woods in the clouds on the way down.

Cautions: The summit is always cooler and sometimes much colder than the floor of the valley, so bring layers and don't overextend yourself. Things can change in a hurry, and if you're sweaty and far from your car you can get in trouble very quickly. And don't be a hero around the waterfalls. Your picture isn't going to be that much better with that extra step forward, and it takes longer to heal at your age.

Diversions: Now we're talking! My all-time favorite diversion is to go to the **World Headquarters of Ben & Jerry's Ice Cream.** You probably passed it in your rush to get to Stowe; what were you thinking? You can get free samples, cones of every flavor, and tours of the factory. The headquarters is on Route 100 just north of I-89 at exit 10.

As you might imagine, there are oodles of things to do in Stowe, including artisan shops, antiques stores, old buildings, gardens, and stuff going on almost every weekend. There are several scenic roads to drive in the valley. Barnes Hill Road has nice views of the mountains, as does Brush Hill Road. Both are on the east side of town.

Nearby: A nice driving route starts in Jeffersonville, goes north on Route 109 to Belvidere Corners, heads east and south on Route 118 to Eden, and then returns to Jeffersonville on Route 100, to Route 100C, to Route 15. If you really want to wander, check out the Green River Reservoir north of Morrisville or Lake Elmore in Elmore State Park east of Morrisville. Why you'd want to leave the Stowe area is beyond me, but if you must, try these two lakes.

XIII. Hazen Notch–Route 58 Area

SPRING ★ ★ ★ **SUMMER** ★ ★ **FALL** ★ ★ ★ ★ **WINTER** ★ ★

General Description: Hazen Notch is a narrow gap between the high peaks of Haystack Mountain to the south and Sugarloaf Mountain to the north. The route provides a nice mixture of rural scenery, mountain views, mature forest, and numerous trails. There are also a number of covered bridges in the area. The Long Trail (LT) cuts across this route at the notch.

Directions: Route 58, Hazen Notch Road, is well marked on both its east and west ends. There are obvious signs along Route 118 in Montgomery Center on the west side and along Route 100 in Lowell on the east. The state park and natural area are at the high point, approximately 5 miles from either side.

Specifically: Hazen Notch (70) is the northernmost of the four back roads that traverse the Green Mountains. Like the other four, it's closed in winter, but for the rest of the year there's much to photograph here. On the west side the road is paved for a short distance as it passes the rushing Trout River. It then turns into a well-maintained gravel road as it climbs to the notch. This part of the road is mostly rural with wild fields and very impressive views of Jay Peak, the dominant mountain of northern Vermont.

Two miles up the road from Route 118 is Rossier Road. This road provides access to the **High Ponds Farm (71),** a private conservation area open to the public. There are very nice woodland trails, old pastures and orchards, and a beaver pond for you to explore. The best views are up

> **Where:** Far northern Vermont near Jay Peak
> **Noted For:** Wildflowers, forest, and views
> **Best Time:** October
> **Exertion:** Easy walking to moderate hiking
> **Peak Times:** Spring: May; summer: June; fall: early October; winter: January
> **Facilities:** None
> **Parking:** Roadside and in lots
> **Sleeps and Eats:** Newport

the Burnt Mountain Trail at Window Rock (1 mile) or on the rocky summit (2 miles). Trailhead parking is in the lot at the end of Rossier Road, 0.5 mile from Route 58. High Ponds Farm and Rossier Road are accessible and open in winter.

The notch itself is well worth wandering. You'll find large boulders strewn in the forest that have come from the looming cliffs to the north, as well as a woodland shelter on the LT a little way downhill to the north. The forest on the east side of the road has been thinned; it looks unkempt and isn't as photogenic as the west-side forest.

Pro Tips: The boulders in the forest at the notch make for great points of interest in forest compositions. They also work well as a background for fern and wildflower pictures. Anywhere along this road in fall will be magnificent. On the west side you'll find the best light in the afternoon; the same holds true for pictures of the cliffs and of Jay Peak.

There is a very pretty little woodland stream on the west side 3.6 miles from the beginning of the road. I have found nice

compositions walking both up- and down-stream along this creek.

The beaver pond at the High Pond Farm is circled by an easy loop trail that's good to walk. There won't be much going on here in the middle of the day, but in the early morning and late afternoon activity increases. I think the last light of the day is the nicest here.

Cautions: There are other trails at High Pond Farm that are only open for winter travel. Please respect the private property. This area is pretty remote, so don't push your luck and don't leave any valuables within sight in your car.

Diversions: Kilgore's General Store in Montgomery Center is a real old-time general store that has a soda fountain and everything that you really need to buy. Go in and have an ice cream float and take a look around the place. You might learn something.

Jay Peak (72) is a few miles north of Montgomery Center on Route 242. In summer and fall a tramway takes visitors and photographers to the top. The rocky summit is just as impressive as the three-state, two-country view. If you don't know what to do in the middle of the day, take the tram to the top of Jay Peak: You'll be in a different world.

Lycopodium

Nearby: There are 25 **covered bridges (73)** within a hour's drive of Montgomery Center. One cluster lies along Route 118 on either side of Montgomery Center, and another cluster between Jeffersonville and Belvidere Center on Route 109. Ask locally for exact directions or peruse the local postcard racks for pictures of them.

Between Troy and North Troy on River Road is **Big Falls (74),** a tumbling waterfall on the Missisquoi River. The river cuts through a rocky gorge where there are three falls and several pools. A sandy beach, the local swimming hole, is at the base of the gorge.

If you're heading south, follow **Route 14 (75)** from Irasburg through Craftsbury, Hardwick, and East Calais. This is a beautiful road (one of my favorites) that can take all day to drive given all the potential stops you can make. **Craftsbury Common** (just off Route 14 to the east) is one of the more picturesque villages in Vermont. Everything here seems as perfect as a movie set. Gleaming white picket fences, colorful flower boxes, beautiful old homes—Craftsbury Common has it all.

If you're heading back to the west, there's an interesting bog and natural area on the south end of **Lake Carmi (76).** Go into the Lake Carmi State Park and ask directions for the nature trail to the cedar forest. On the trail you'll walk through lush meadows, ferny glens, and finally an interesting cedar wetland. The road to the camping area crosses a very large bog with stunted tamaracks and mats of sphagnum moss. There's no trail into this bog, but you can do bogscapes from the side of the road. Keep your eyes open for wildlife; you never know what you're going to see in a bog!

XIV. Route 232, Groton State Forest Area

SPRING ★ ★ ★ SUMMER ★ ★ ★ FALL ★ ★ ★ ★ WINTER ★ ★ ★ ★

General Description: Route 232 traverses **Groton State Forest (77)**, providing access to several beautiful boreal lakes and streams with lots of trails and a well-known lookout on top of Owls Head Mountain. There's also a large bog that's remote and very wild.

Directions: Route 232 is well signed where it turns north from Route 302 west of Groton and south from Route 2 east of Marshfield. All other locations are well marked from Route 232 within the forest. Osmore Pond is located in New Discovery State Park, a small inholding within the state forest.

Specifically: This is a fabulous state park well known to Vermont photographers as one of the best places to be no matter the season. The forest here is boreal, with more spruce and balsam trees than hardwoods. The contrast between the dark conifers and colorful beeches and maples is great in any season, but especially so in fall and winter. If you hit a good day here, there's no better place to be in Vermont—and perhaps all New England.

The premier spot in the forest is **Owls Head (78)**, a rocky nubbin of a mountain that has a road mostly to the top. From the trailhead parking lot, the short trail to the top is on your left; the trail on your right leads to another, lower lookout where there's a picnic pavilion. The view from the top is best due west over Kettle Pond with the distinctive outline of Camels Hump Mountain on the horizon. The lower lookout has a nice but more obstructed view south.

Where: Between Groton and Marshfield
Noted For: Lakes, lookouts, landscapes
Best Time: Early October
Exertion: Minimal to moderate
Peak Times: Spring: mid-May; summer: June; fall: early October; winter: January
Facilities: In park
Parking: In lots
Sleeps and Eats: Montpelier

Kettle Pond and **Osmore Pond (79)** are both wild small lakes ringed by beautiful forests and easy trails. Anywhere along these part-rock, part-tree lakeshores will be good for photography, but don't overlook the forest. There are delicate little flowers, bright berries, mushrooms, birch bark, and lush ferns, among lots of other things. Early in the morning is the best time to photograph the lakes, especially when the wind is down and mist is drifting about.

Pro Tips: If it's raining or snowing and you're anywhere in the vicinity, head for the forest at once. The boreal forest turns into a lush, mossy wonderland when it's damp, and the hues of the woods are at their richest. This is also true for bogs. The state forest is very popular with snowmobilers, which means those who are stuck on foot will find the trails nicely packed for easy walking.

The access road to the Owls Head parking lot is gated and opens too late for the best light on top. Despite what the signs say, the gate is opened at purely random times—which means later than you

want. If you want to get to the top for early light (and you do want to do that), you'll have to walk about a mile. On top, use the cracks in the bedrock as leading lines to give your foreground some interest. This is a morning shot; in the afternoon you'll be looking into the sun.

Trails: The easy trails around Osmore Pond (2 miles) and Kettle Pond (3 miles) are both worth wandering. Expect to take the better part of a day to really get the most out of them. A back trail up Owls Head that starts at the New Discovery State Park is 1.5 miles long. Also in the park is a trail up Big Deer Mountain that's well known for its pink lady's slippers in early June.

The wandering 2.5-mile-long trail to **Peacham Bog (80)** starts at the nature center on the back side of Lake Groton. The trail doesn't seem to go anywhere beyond the bog, but once you reach the bog you won't care. This is a very little-visited area, so you're likely to have it to yourself. There's no boardwalk through this bog, but if you have high boots and step carefully it's possible to carefully explore it. Lady's slippers, pitcher plants, and bog rosemary grow here, as do both white- and purple-fringed orchis.

Cautions: Be careful here during hunting season (most of November and early December) so you aren't mistaken for a deer. Summers can be a bit hectic, but as soon as you start off on a trail you'll have the place to yourself. The bugs (mid-May into June) can be brutal. Wear dark-colored long sleeves and pants and try every repellent you can find. None will work, but by the time you figure that out the season will be over.

Nearby: The well-photographed village of **Peacham (81)** isn't far to the east, but you really can't get there very easily from here. Either go up to Danville and then south on Peacham Road or go down to Groton and then north on Peacham Road. The standard shot is up behind the church looking out over the hills beyond. It's worth your time to explore all the back roads in the area, and to visit South and East Peacham as well.

Noyes Pond (82) is an isolated part of the state forest accessed from Route 302 near West Groton on Seyon Pond Road. Go here when the summer crowds are too much for you in the main part of the park.

September forest, Kettle Pond

XV. Greater Burlington Area

SPRING ★ ★ SUMMER ★ ★ ★ ★ FALL ★ ★ ★ WINTER ★

General Description: The Burlington area, although growing rapidly, is rich in historic sites and wonderful old buildings. Within the city and close by there are also pocket-sized natural areas including a bog, a marsh, a couple of lakes, a river gorge, and several lakeside parks.

Directions: Shelburne is 7 miles south of Burlington on Route 7. Colchester is the next township north of Burlington—the bog and causeway are just north of the mouth of the Winooski River, while the pond is a bit east of the town of Colchester. The mill and gorge are in Jericho about 10 miles east of the city on Route 15. Sandbar State Park is north of Burlington where Route 2 crosses Lake Champlain to South Hero Island. Detailed directions are given after each location write-up.

> **Where:** Northwest Vermont on Lake Champlain
> **Noted For:** Cultural and natural sites
> **Best Time:** Summer
> **Exertion:** Minimal to easy walking
> **Peak Times:** Spring: May; summer: June; fall: October; winter: December
> **Facilities:** At developed sites
> **Parking:** In lots
> **Sleeps and Eats:** Many in Burlington
> **Sites Included:** Shelburne Farms (83), Shelburne Museum (84), LaPlatte River Marsh Natural Area (85), Shelburne Bay Park–Allen Hill (86), Shelburne Pond (87), Colchester Bog (88), Colchester Pond Natural Area (89), Old Mill Park (Old Red Mill) and Browns River Gorge (90), Burlington Bike Path Causeway (91), Ethan Allen Homestead (93), Other City Parks

Specifically: Burlington is a lakeside city surrounded by agriculture and small woods and backed by the rise of the Green Mountains. There is a little bit of everything within a short drive of town, though the cultural landscape photography is particularly good. The Shelburne Museum, an outdoor museum dedicated to preserving the cultural history of Vermont, and Shelburne Farms—a national historic landmark—are beyond grand.

Shelburne Farms (83)

Shelburne Farms, a magnificent dairy farm started by William Seward and Lila Vanderbilt Webb in 1886, is still a working dairy farm, but it now has a strong en-

vironmental educational component as well. Combining their enormous fortunes, Seward and Webb built a property that is so far beyond the connotations of *farm,* it boggles the mind. These two did what God would do if He could afford it.

On its 1,400 acres are rolling pastures bordered by open woodlots, miles of walking paths, and some of the grandest buildings you can imagine. Top it all off with stunning lakeside views and the distinctive outline of Camels Hump on the eastern horizon and you have a special slice of heaven right here in Vermont.

There are four barns here that are best described as huge wooden castles: the main farm barn, a coach barn, a breeding barn, and the old dairy barn. The first two

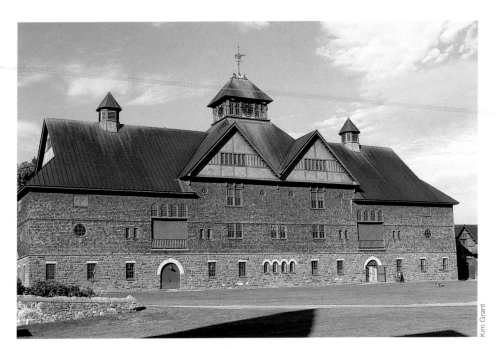

Shelburne Farms

are open to the public and full of wonderful pictures. Between the barns are winding roads and trails that lead you from one stunning scene to another. The crown jewel of it all is the original lakeside cottage, a turn-of-the-20th-century estate house that's now a luxurious inn.

All visitors start at the welcome center on Harbor Road. If you're a walker, there are trails that start here and go to all corners of the property. The farm barn is about a 0.5-mile walk; the inn, not quite 2 miles. If you don't want to walk, there's a regular tractor-pulled wagon service that you can take on a tour or on a ride to the lake and inn. Cars are not allowed on the roads unless you have reservations at the inn for the night or for a meal.

Directions: The town of Shelburne is on the Route 7 about 7 miles south of Burlington. The welcome center at Shelburne Farms is 1.5 miles west of town on Harbor Road at the intersection of Bay Road.

Shelburne Museum (84)

Now, it may seem odd to list a museum in a photographer's guide, but this is no ordinary museum. On 45 acres there are 37 historic buildings collected from all over New England. In the buildings are stunning collections of art, crafts, and Americana. Not impressed yet? Read on.

The grounds include the old ship *Ticonderoga*, the Colchester Reef Lighthouse, a 1915 locomotive and a round barn, a sawmill, a Shaker sled, and an old carousel as well as many other period buildings, flower and herb gardens, and an apple orchard. The indoor art includes paintings by Rembrandt, Monet, Manet, Degas, Mary Cassatt, and Winslow Ho-

mer and collections of carriages, quilts, decoys, trade signs, and cigar store figures, among others.

I think the best photographs to be taken here are the pieces of the scene. You probably won't capture any big sweeping landscapes, but you will do flowers against on old fence, barnside details, abstracts with the lighthouse and the *Ticonderoga*, and window reflections in the old buildings. You'll excel here if you let yourself play photographically and see things differently. There is an entrance fee, but it's good for two days.

Directions: The town of Shelburne is on Route 7 about 7 miles south of Burlington. The museum is on the south side of town on Route 7.

LaPlatte River Marsh Natural Area (85)

This 211-acre wetland and floodplain is owned by The Nature Conservancy and protects the mouth of the LaPlatte River and the backwater of McCabes Brook. This is a preserve for people who enjoy all the quiet water, cattails, snags, and animals of a wetlands.

There are two ways to see this preserve. A 15-minute trail wanders alongside the water's edge and offers frequent views of the marsh. The woods here aren't very attractive, though, until you get near the end of the trail. The best snags and trees and marsh scenes are where the trail loops around and starts heading back to the parking area.

Alternatively, you can paddle these waters. I think this is the best for both wildlife viewing and photography because you'll be able to cover much more territory—McCabes Brook and the LaPlatte River—and you'll be able to get closer to your subjects.

The best time for canoeing is in spring when the water is high and it's easier to get around and over the downed logs. High water makes the trail very wet in spots, however, so wear high boots if you're walking the trail.

Directions: Follow Route 7 for 1.8 miles north of the center of Shelburne to Bay Road. Turn left and go 1 mile to a bridge over the LaPlatte River. Park in the fishing access lot on the far side of the bridge.

Shelburne Bay Park–Allen Hill (86)

This lakeside park is across the road from the LaPlatte River Marsh Trail—but it's completely different from that preserve. Shelburne Bay Park is a narrow strip of hardwood forest along the shoreline of Lake Champlain. On the back side of the park are fields and scattered trees with picnic tables and a graded recreation path.

The attraction here is not so much the shore as it is the forest—a nice patch of mature hardwoods well known for its spring wildflowers. A network of trails weave through the forest and lead eventually to Allen Hill, a steep but short rise at the end of the park. It is about a 20-minute walk on the forest trails to get to Allen Hill and about 15 minutes back on the bike path. These woods seem to be a bit more wild and less tended to than those at Shelburne Farms, so I'm guessing the wildflowers will be much better here.

Directions: Follow Route 7 for 1.8 miles north of the center of Shelburne to Bay Road. Turn left and go 1 mile to a bridge over the LaPlatte River. Park in the trail-

head lot on your right just beyond the fishing access lot.

Shelburne Pond (87)

This pond and its surrounding woods comprise the Laurence Achilles Natural Area, which is administered by The Nature Conservancy and the University of Vermont. This is the spot to go to when Shelburne is hopping with tourist cars and tourist buses: Only the locals know about it.

The pond is pretty big and pretty nice, with farmland bounding one half and forest on the other. From the fishing access parking lot, a trail leads off into the woods and roughly parallels the edge of the pond. Wildflowers are nice here in spring, as are fall colors in October.

Shelburne Pond is best at dawn when the first light of the morning strikes the still water and the trees are softly lit. Even in the middle of summer when this part of the Champlain Valley can be crazy, Shelburne Pond will be serene and worth a visit.

Directions: From the main intersection in Shelburne, take Falls Road south for 0.8 mile and turn right onto Irish Hill Road. Follow Irish Hill Road (it changes to Pond Road) for 3.2 miles to the short access road to Shelburne Pond on your left.

Colchester Bog (88)

This bog is a University of Vermont natural area and—at 184 acres—relatively large. At first it will look like a wild tangle of shrubby vegetation, but if you think small there's lots to photograph. In particular, look for the insectivorous sundews and pitcher plants that are charac-

Snowy owl, Sandbar State Park

teristic of bogs. They're usually tucked down into the thick mat of sphagnum, but if you look carefully they aren't too hard to find.

The best access is from the floating boardwalk off the main trail. There are a number of clumps of pitcher plants near the end of this boardwalk. The Burlington Bike Path also cuts through the bog, but the vegetation is even thicker here than along the main path or boardwalk. Surrounding the bog is an interesting sandy woods that in April and May features nice wildflowers.

Directions: The bog occupies the very tip of the Colchester Peninsula, northwest of downtown Burlington. From Route 127, take Porter's Point Road to Airport Road and park at Airport Park, the large area of playing fields on your right. Facing the fields, walk left (west) around the children's playground along a path between the ball fields. Bear right on the path at the edge of the woods and then immediately left at the fork as the path enters the woods. The trail around the bog is 50 yards ahead. The boardwalk is a short distance to your right.

Colchester Pond Natural Area (89)

This 693-acre island of wildness in a sea of farms and new housing is part of the Winooski Valley Park District. You'll find a mixture of old and disturbed forest, wild meadows, and a mile-long lake to explore. There's one trail that goes around the lake—but not completely around, so you'll have to backtrack to return to your car.

The best thing to do is start walking and then wander when you find a good area that interests you. In spring there are lots of wildflowers; in summer, reflections on the lake and details in the forest. The fall colors here are very nice because of the mixed forest types, and in winter you'll find patterns in the ice and tracks in the meadows.

Directions: From Colchester Village, go north on East Road and turn right onto Depot Road. Follow Depot left at the fork to Colchester Pond Road. The small parking area is to your left, 0.2 mile ahead.

Old Mill Park (Old Red Mill) and Browns River Gorge (90)

Vermont photographers know this as the Old Red Mill, one of the most photographed structures in Vermont. And it is a building worthy of such a distinction, rising as it does above the rocky course of Browns River. To make it even better for photographers, the mill is right beside Route 15, the main road between Burlington and St. Johnsbury. The best view of the mill is from the footbridge over Browns River next to the highway bridge. Go in the morning and wait for blue sky behind the red building for the best picture.

Don't leave after you take the picture of the mill, though. Behind the mill is a little preserve that runs along the river. Photographers will love the rocks in the river because they are sculpted into wonderfully fluid shapes. Shoot them as abstracts or use them as foregrounds for bigger scenes.

When you're finished with the river and rocks, look for wildflowers in the woods (pink lady's slippers bloom here in June), then walk farther down the river to a small waterfall and a beaver pond at the end of the trail. Chances are you'll have these woods and the river to yourself, especially if you come in spring or the fall.

Directions: The mill is on the west side of the little town of Jericho, east of Essex Junction on Route 15. Park behind the mill. The trail along the river starts from the corner of the lot near the river.

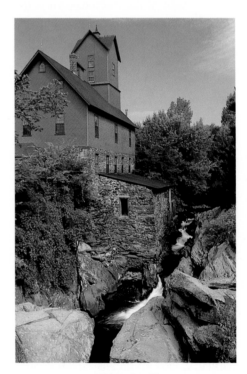

Old Red Mill

Burlington Bike Path Causeway (91)

The causeway is an old railroad bed that once connected the Colchester Peninsula with South Hero Island. It's now a bike path that extends about a mile into the lake; it's a very popular spot for runners, walkers, anglers, and bicyclists.

There are no old buildings here, nor is there much nature to be found unless you count gulls and a few bobbing ducks. The attraction is sunrise and sunset, because you can get down to the water's edge and get unbelievable reflections. It's best to come when the lake is calm, but if it isn't, there will be as much color in the water as there is in the sky. Besides, the exercise is good for you.

Directions: From Route 127 in Colchester, take Porters Point Road to Airport Road. Airport Road turns into Colchester Point Road after Airport Park. Bear right onto Mills Point Road at a fork and park in the lot shortly ahead where the bike path crosses the road.

East Woods Natural Area (92)

Engulfed by rabid development, East Woods is an oasis in a sea of shopping and suburbs. This little University of Vermont preserve may not seem like much when you consider all the forestland in Vermont, but if you're stuck along the South Burlington/Route 7 strip and want something to do, East Woods is for you.

The 40 acres of mostly pine-hemlock woods is best on a rainy spring or early-summer day when all the green leaves are glowing green. In April and May wildflowers can be found, and Potash Brook at the end of the trail will be running. In fall the combination of brightly colored leaves mingled with pine needles on the forest floor can be very compelling, and after a rainy period there can be many mushrooms on the forest floor.

Directions: The trailhead parking area is on Swift Street, which turns east off Route 7 0.1 mile south of the I-189/Route 7 intersection.

Ethan Allen Homestead (93)

The park, occupying the floodplain forest and meadows on a narrow peninsula in a tight bend of the Winooski River, is another of the many nice parks of the Winooski Valley Park District. It preserves the last home of Ethan Allen: part patriot, part scoundrel, and one of the forces behind the founding of Vermont.

The park is primarily an effort to restore and bring to life Allen's 18th-century home and farm. His house, built in 1787, and gardens are the centerpiece, but there are also displays, living history exhibits, and several trails that lead to the rest of the property.

There are two primary trails: A peninsula trail goes out to the bend in the river through hay fields, wild meadows, and woods of ash and willow, while a wetlands trail makes several loops through a small wetland and cattail marsh. Both are worth walking in all seasons. My favorite time to come is early in the morning after a rain or heavy dew when everything is wet and glistening.

Directions: Take Route 127 north from Burlington to the North Avenue and Beaches exit, about 1 mile. You'll see the sign and turn to the homestead at the top of the exit—if you get to North Avenue, you've missed it. The parking lot is 0.5 mile ahead.

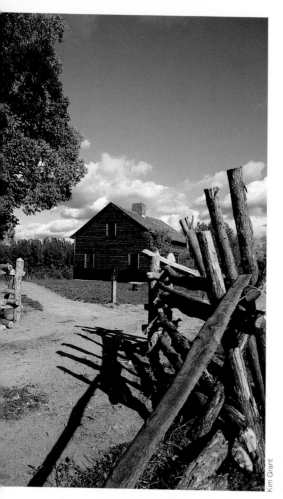

Ethan Allen Homestead

Kim Grant

are of the river. There are some cascades here, and a bit of a gorge, and if the river is running high it can be pretty exciting. This area straddles the river and is on both sides of the Route 2 bridge between the cities of Burlington and Winooski.

Macrea Farms Park (96) is farther downstream on the Winooski and much more serene and natural. A farm gone wild, this park is a maze of high grass, slow backwaters, and spreading trees. Go for a wander and see what you can find. This is a good spot for a canoe and a lazy summer day. This park is at the end of MaCrea Road, which intersects Route 127 in Colchester.

Delta Park (97) is at the mouth of the Winooski River. Most of it is impenetrable cattail and shrub marsh, but the bike trail cuts through and gives access to the sandy riverbank. At the river you can walk right along the beach and out to the lake to a narrow sandy spit. This walk is sometimes restricted because it's a critical nesting area for several animals. Follow Windermere Road from Airport Road near Airport Park and the trail to Colchester Bog to get to Delta Park.

Recommendations: The best light on the barns and the inn at Shelburne Farms is first thing in the morning. There's also a very nice view of the farm from Lone Tree Hill behind the big farm barn. In late afternoon the inn is very nice with the flower gardens as a foreground; the rocky beaches on either side of the inn make good places to shoot the sunset.

In the Shelburne area, if it's going to be a sunny summer day go to the LaPlatte River marsh at dawn and then walk to the farm barn for the early-morning light, or go to Allen Hill and photograph flowers

Other City Parks

Several small city parks are worth visiting if you have time and the conditions are good. **Oakledge Park (94)** is mostly tennis courts, but a narrow strip of undeveloped land along the lakeshore is good for sunsets. Oakledge Park is at the southern end of the lakeside bike path.

Salmon Hole Park and the **Winooski Natural Area (95)** are neighboring parks in the middle of the city along the Winooski River. The best photographs

and forest details. If you're here on a cloudy day, I suggest lingering on Allen Hill and then going to the museum for details and close-ups. There will be far fewer people at the museum on a cloudy day than a sunny one.

In the Burlington area I like to go to Ethan Allen's place in any weather. On clear days I photograph the cabin and gardens with the sky. If there are white skies I'll either move in closer and photograph details or walk one of the trails. The wetland trails are best from April through June. The cabin looks best in the morning.

When you can't stand the crush of Burlington, go to Colchester Pond if you're a real hermit or go to the Old Mill if the day is sunny. Remember, it's best in the morning. If you've just gotten out of a meeting and want to grab a sunset shot, go to either Oakledge Park for a natural picture or the waterfront if you want city lights in your composition.

Pro Tips: I suggest you stand well away from the buildings at Shelburne Farms to get your best shots. I usually stand several hundred yards away to get the buildings and some of the surrounding fields and woods. If you stand too close, your picture will be distorted and you'll lose the context of the scene.

In summer and fall carriage rides are offered to guests of the inn. This makes for a good picture opportunity. Try to set up your shot so that you have the inn and the carriage together. The curved drive approaching the inn makes a perfect setting for this shot.

If it's windy and you want to photograph wildflowers in the Shelburne area, go to either Allen Hill or Shelburne Pond—both sites are protected from the prevailing north and northwest winds. If the wind is blowing from the south, then work the north side of Allen Hill or the deep forests at Colchester Pond.

Cautions: The bugs will be bad around the LaPlatte River Marsh and in the floodplain forest parks along the Winooski River in May and June—be prepared. Still, this is the best time to photograph in the marsh and forests, so wear long sleeves and pants and bring a lot of bug repellent.

There is unfortunately graffiti on some of the rocks in the Browns River behind the mill; you'll want to look carefully so that it doesn't get in your pictures. Look closely as well for power lines across the river sneaking into your pictures.

Burlington is a pretty safe city, but moderate caution when leaving your car is always a good idea. Make sure no valuables are visible inside the vehicle, and don't wander by yourself if something is making you feel uneasy. I've never had a problem, but I'm a crusty old man. Take care and you won't have a problem, either.

Nearby: The Vermont Teddy Bear Company is just south of the Shelburne Museum and is another extremely popular tourist destination. Mount Philo, a few miles south on Route 7, is a great place to wait for sunset with a picnic dinner.

In the middle of Burlington is a pedestrian mall that leads down to the lakeshore. It's a fun place to hang out, eat, shop, and do as little as possible. There's a farmer's market every week here as well, and all kinds of real Vermont characters to talk to.

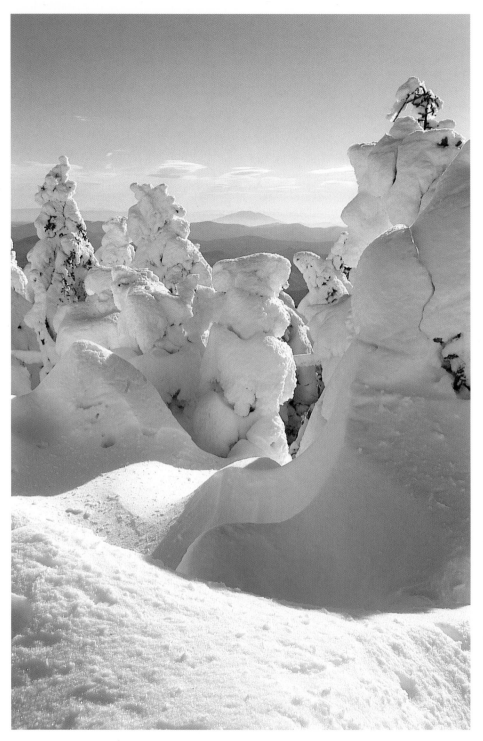

View of Mount Ascutney from the top of Killington Peak

Right Down the Middle of Vermont

XVI. Route 100

SPRING ★★ SUMMER ★★★★ FALL ★★★★ WINTER ★★

General Description: Route 100, following the mountainous spine of the state from Canada to Massachusetts, is the most renowned scenic road in Vermont. It's Vermont's version of the Blue Ridge Parkway and Trail Ridge Road (without the frilly name) that all visitors are told to drive while in the state. All along this route you'll find quaint villages, roaring brooks, blue mountain lakes, dense forests, and mountaintops peeking out of the treetops.

There are lots of things to photograph, too, and as many times as I have traveled this road, I always find new ones. It looks different in the morning than it does in the afternoon, different going north than going south, different in summer than it does in fall, different on a sunny day than it does in the rain, different from one week to the next. Drive it, repeatedly, and you'll see.

You must be willing to turn around (safely!) and go back to the shot you just drove past to get your best photographs on Route 100. Otherwise you'll go speeding right past shot after shot and miss everything. There are lots of places to park but not always exactly where you want them, so a bit of walking may be necessary. Be careful when parking or walking along Route 100: There can be cars, tractors, snowmobiles, and large trucks.

I particularly like the Lincoln Gap Road, Moss Glen Falls in Granville, Texas Falls on Route 125 (the Middlebury Gap Road), the gondola to the top of Killington Peak, Plymouth and Calvin Coolidge State Historic Site, Jamaica State Park, the area around West Dover, and Wahoo's Eatery east of Wilmington. Every mile of the route, you're likely to find something to photograph.

Don't drive this road if you're in a hurry. Drive it, instead, when you have all day and lots of curiosity to explore. The more time you take on Route 100, the more pictures you'll find, and the better your pictures are going to be.

Directions: If you're in western Vermont go east; if you're in eastern Vermont go west. You can't help but bump into Route 100.

Northern Part—I-89 to Route 4

North of the starting point are two areas of interest to photographers. The first is the little mountain village of **Stowe** and neighboring **Mount Mansfield.** A detailed description is provided in chapter 12 of this book. The second place is the **World Headquarters of Ben & Jerry's Ice Cream,** less than a mile north of exit 10 off Route 100. Look for tours, Ben & Jerry's gifts, and all the free tastes you want. You can also have a cone or 12. Take a break and enjoy a cone!

0.0 miles

Exit 10 off I-89. Turn south toward Waterbury and start following Route 100.

8.3 miles

Route 100 turns south at the stop sign and begins to follow the Mad River through the beautiful **Mad River Valley.**

9.0 miles

There's a scenic farm with three silos on the west side of the road. Shoot it from the north to put the mountains behind it.

12.5 miles

Waitsfield (99). Waitsfield is the home of Mad River Canoes. The entire valley is worth exploring. I usually take **North Road,** which parallels Route 100 on the other side of the river. There are **two covered bridges** and three valley walking paths in the area and lots of pretty river and rural scenes. Ask locally for directions.

13.5 miles

Route 17 intersects to the west and rises over **Appalachian Gap** to the west-side town of Bristol. It's a very pretty drive and can be magnificent in October. The Long Trail (LT) crosses at the gap, allowing exploration on foot both north and south. The road is open all year and paved its entire length.

17.5 miles

The next 5 miles is a pretty wooded section of the road that crosses the river a number of times. There are several good access points and lots of riverscapes and details to photograph.

18.2 miles

The quaint village of **Warren** and the **Roxbury Covered Bridge** are on the other side of the river.

18.9 miles

Lincoln Gap Road intersects to the west. This is one of my favorite roads in Vermont because of its rural and rugged mountain scenery. The road isn't paved on either side of the gap near the top, and it's closed in winter, but that just means most people will take other roads—and you'll have this one to yourself. The LT crosses at the gap allowing exploration on foot both north and south. See chapter 11 for more details.

22.4 miles

This marks the end of the Mad River drainage and the beginning of the White River drainage. For the next 6 miles Route 100 passes through a densely wooded notch with a meandering stream and several little beaver ponds.

26.2 miles

Moss Glen Falls (100). This waterfall is best in June and then after a good rain in early October. You can shoot from the boardwalk, but I think the best shots are from along the stream or in front of the boardwalk. Remember, you don't have to include the top of the waterfall in your composition. The lower parts of the falls—the pool and outlet stream—are the prettiest parts.

31.0 miles

You've reached the beginning of the broad **White River Valley,** with nice farms and bucolic scenes wherever you look for the next 14 miles.

32.9 miles

Reach the intersection of Route 125, **Middlebury Gap Road (101),** to the west. Near the top of this route is the short road north to **Texas Falls (101),** a narrow chasm with a tumbling stream go-

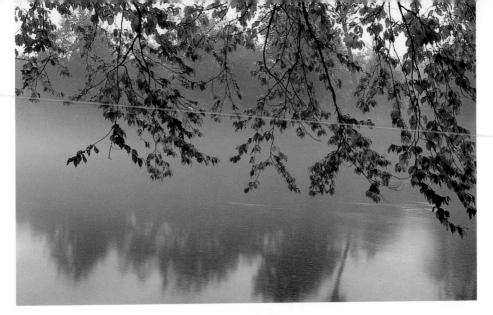

White River

ing through it. There's a circling nature trail, picnic facilities, and nice forest there as well. The best shot of the falls is from the little wooden bridge that crosses the stream just below the falls.

37.0 miles
Rochester. This is a beautiful little town with white homes and businesses surrounding a nice village green.

37.9 miles
The intersection of Route 73, **Brandon Gap Road.** At the gap lie Mount Horrid and the Great Cliff Trail, a strenuous but short trail to a magnificent lookout. This is also a peregrine falcon nesting area in summer.

44.7 miles
Immediately over the bridge there's a dirt road to your right that travels back along the river. Good access points and lots of river scenes to photograph.

55.1 miles
The beginning of a little patch of old-

growth forest lies on the east side of the road in **Gifford Woods State Park (102).** Old hardwood forests like this are very unusual in Vermont. There are no trails, but the walking is easy. Try not to trample anything, and leave no trace of your visit in this very special forest.

56.0 miles
The intersection of Route 4 in Sherburne.

Southern Part—Route 4 to Route 9

0.0 miles
The Route 4/Route 100 intersection at Sherburne near Killington. Route 100 follows Route 4 east for the next 6 miles. The access road to **Killington ski area (103)** turns south here and climbs to the base of the ski area. In summer and fall the gondola is open for lifts to the top, where bird's-eye views and walking trails can be found. The trail to the true top of the mountain leads you up the metal stairs from the top of the gondola and then quickly to the rocky summit. The summit

Near Weston

forest is spooky when it's in the clouds, and the view is magnificent when it's clear.

6.1 miles
Route 100 turns south off Route 4 at Bridgewater Corners.

8.1 miles
Woodward Reservoir. This is a good spot for afternoon reflection shots.

9.2 miles
CCC Road to North Shrewsbury. This road is closed in winter, but in-season it's a good way to avoid the traffic of Route 100 and discover some mostly forgotten rural countryside on the south side of Killington Peak.

11.3 miles
Junction of Route 100A in Plymouth Union. Less than a mile north on Route 100A is the restored homestead and village of President Calvin Coolidge, now a **state historic site (104).** This small group of buildings is very pretty and worth the stop if you like old buildings in picturesque settings.

14.6 miles
Amherst Lake marks the beginning of a string of narrow, **roadside lakes** cradled between steep wooded ridges. Amherst Lake is first, then Echo Lake (Echo Lake, Echo Lake), followed by Lake Rescue and Reservoir Pond. There are lots of possibilities here—reflections, summer cottages, boats, fall color, and winter ice-fishing huts—but the problem is finding a place to park. Don't park along the road unless you're in an official pullout. There are some smaller roads that may provide a few limited places to park.

19.9 miles
The junction of Route 103. Route 100 follows Route 103 east for less than 2 miles to the town of Ludlow. **Okemo Mount ski area** is on your right; in summer and fall you can take a lift to the top of the mountain. Route 100 turns south under a tall train trestle in the middle of Ludlow.

31.5 miles
Weston (105). The picturesque village of Weston is one of my favorite places to go. There are beautiful buildings, a tree-lined green with a little white bandstand, a nice white church, big barns, old stone walls, and lots of stores to keep the nonphotographers happy.

Weston is also the home of the **Vermont Country Store (106),** the mother

ship of all Vermont country stores. It's much more commercial than the little ones you'll find out in the wilds, but you'll find everything you could possibly want plus everything you forgot you wanted. I usually try to stop by around noon when they have lots of free samples of their wonderful gourmet foods available for sampling. Free food, a quaint town, and an empty road ahead . . . sounds like a slice of photographer's heaven.

36.8 miles
Route 100 jogs right (west) here in Londonderry for 0.4 mile and then turns south again.

37.5 miles
For the next mile, this is a very pretty section of the West River.

43.8 miles
The junction of Route 30 in Rawsonville. Route 100 follows Route 30 east for the next 8 miles.

48.6 miles
Jamaica is another pretty Vermont village with overgrown gardens and brightly colored fences and signs. On the north side of the West River is Jamaica State Park, a magnificent place for walkers, runners, picnickers, and photographers. See chapter 4 for more information on this park.

51.7 miles
Route 100 turns south off Route 30 and crosses a one-lane bridge over the West River. Immediately on the far side of the bridge, a little road to your left gives good access to the river. There are lots of tall wildflowers here in summer, and colorful leaves in quiet pools in fall.

52.0 miles
The road follows a scenic section of Wardsboro Brook.

56.0 miles
Route 100 snakes through the little village of Wardsboro.

60.4 miles
Reach the junction of the Kelly Stand Road (also called Stratton Road). This road leads around the south side of Stratton Mountain to the east-side village of Arlington. Grout Pond is near the high point, as is Forest Service Road 71. See chapter 2 for more details.

63.3 miles
Route 100 reaches a little crest and begins to drop down into the North Branch of the Deerfield River drainage. The next 10 miles are mostly nondescript Mount Snow ski area development, but there are also a few nice old inns and enough old barns and woodlots to keep most photographers happy. Two inns of special note—the Inn at Sawmill Farm and the Hermitage Inn (107)—are beyond magnificent in their appearance and level of service. There may be no two finer places to stay or dine in Vermont. Okay, don't believe me, go see for yourself.

65.2 miles
The access road to Mount Snow ski area (108). Like all the major ski areas in Vermont, this one offers rides to the top of the mountain in summer and fall; there are also many ski and hiking trails to wander. Ski areas are great places to get shots of the cross section of the forest from a ski trail. Look for backlit scenes for a bit of added drama.

74.0 miles
Wilmington and the intersection of Route 9. Wahoo's outdoor eatery is a few miles to the east. Save a place for me.

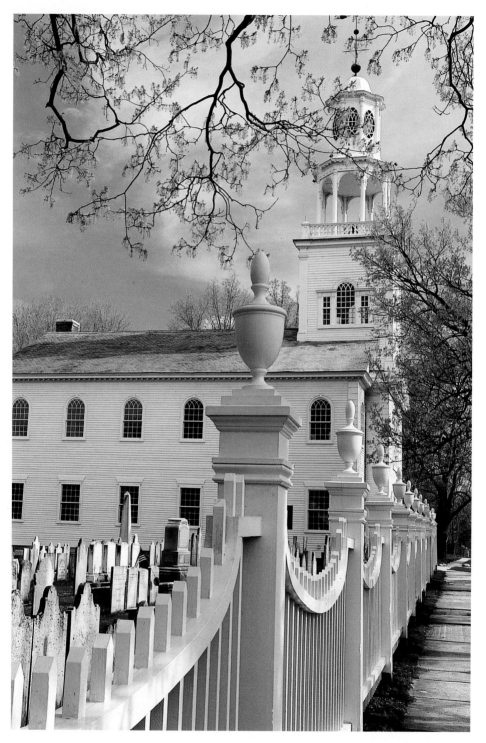

First Church, Bennington

XVII. Favorites

Favorite Churches

1. Middleton Springs
2. Benson
3. Manchester Village
4. First Church, Bennington
5. Landgrove
6. Richmond
7. Peacham
8. Lunenburg
9. Craftsbury Common
10. Newfane
11. South Woodstock
12. Albany
13. Barnard
14. Chelsea
15. Waits River

Favorite Lakes

1. Branch Pond, Kelly Stand Road
2. Emerald Lake, East Dorset
3. Lefferts Pond, Chittenden
4. Maidstone Lake, near Guildhall
5. Kettle Pond, Groton State Forest
6. Osmore Pond, Groton State Forest
7. Sterling Pond, Smugglers Notch
8. Grout Pond, Kelly Stand Road
9. Lake Champlain
10. Lake Willoughby, near Barton

Favorite Quaint Villages

1. Grafton
2. Woodstock
3. Dorset
4. Peru
5. Landgrove
6. Peacham
7. Bristol
8. Weston
9. Barnard
10. Waits River

11. Townshend
12. East Corinth
13. Tunbridge
14. Middlebury

Sunset Locations

1. Mount Philo, near Charlotte
2. Shelburne Inn, Shelburne
3. Knife-edge of Mount Equinox
4. Branch Pond, Kelly Stand Road
5. Lake Bomoseen, Castleton
6. Route 2 causeway to South Hero Island

Sunrise Locations

1. Shore Acres, North Hero Island
2. Grout Pond, Kelly Stand Road
3. Old Railroad Causeway, Burlington

Mountaintop Views

1. Mount Mansfield, Stowe
2. Mount Philo, near Charlotte
3. Owls Head, Groton State Forest
4. Burke Mount, East Burke
5. Jay Peak, near Troy
6. Mount Equinox, Manchester
7. Mount Abraham, near Lincoln
8. Mount Olga, near Wilmington
9. Black Mountain, Dummerston
10. Mount Hunger, Stowe

Favorite Roads

1. Kelly Stand Road
2. Mount Tabor–Weston
3. Lincoln Gap
4. Route 232, Groton State Forest
5. Cloudland Road, Woodstock
6. Route 14, north of Montpelier
7. Route 108, Smugglers Notch
8. Route 17, Appalachian Gap west

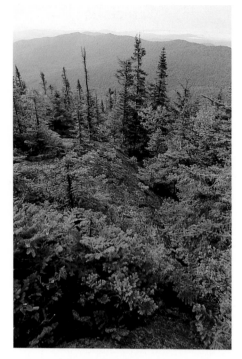

Burke Mountain

14. Village Bridge, Waitsfield
15. Middle Bridge, Woodstock
16. Larkin Bridge, Tunbridge
17. East Salmon Bridge, Weathersfield
18. Slaughter House Bridge, Northfield
19. Scribner Bridge, Johnson
20. Warren Bridge, Warren
21. Kidder Hill Bridge, Grafton
22. Emily's Bridge, Stowe Hollow

Favorite Wildflowers for Photographers

1. Red trillium
2. Pink lady's slipper
3. Showy lady's slipper
4. Milkweed
5. Painted trillium
6. Apple blossom
7. Bloodroot
8. Black-eyed Susan
9. Hepatica
10. Trout lily
11. New England aster
12. Daisy

9. All of Route 100
10. Route 35, Townshend to Grafton
11. Route 121, Grafton to Lawrence Four
 Corners
12. Route 12, north of Montpelier

Favorite Covered Bridges

1. Codding Hollow Bridge, Waterville
2. Foster Bridge, Cabot
3. Cold River Bridge, North Clarendon
4. Green River Bridge, Guilford
5. Upper Bridge, Northfield
6. Silk Bridge, Bennington
7. C. K. Smith Bridge, South Randolph
8. Bridge on the Green, West Arlington
9. Paper Mill Bridge, Bennington
10. Coburne Bridge, East Montpelier
11. Thetford Center Bridge, East
 Thetford
12. Worrall Bridge, Rockingham
13. Cooley Bridge, Pittsford

Favorite Nonphotography Places

1. Ben & Jerry's World Headquarters,
 Waterbury
2. Vermont Country Store, Weston
3. VINS, Quechee
4. Green Mount Audubon, Huntington
5. Orvis, Manchester
6. Fairfax Museum, St. Johnsbury
7. Shelburne Farms, Shelburne
8. Shelburne Museum, Shelburne
9. Montshire Museum of Science,
 Norwich
10. Woodstock Farmer's Market,
 Woodstock
11. Cabot Cheese Factory, Cabot
12. Tunbridge World's Fair, Tunbridge
13. Gillingham's General Store,
 Woodstock
14. Hector's, Burlington

My Personal Favorites

1. Kelly Stand Road
2. Jamaica State Park
3. Shaw Mountain Nature Conservancy Preserve
4. Grafton area
5. Groton State Forest
6. Woodstock area
7. Mount Mansfield
8. My backyard

Favorite Rural Landscapes

1. Pleasant Valley, near Jefferson
2. Mettawee Valley, near Dorset
3. Lincoln area
4. Victory Basin
5. Route 17, Addison to Bristol
6. Pomfret area
7. Grafton area
8. Route 22A, Shoreham to Charlotte
9. Craftsbury area
10. Peacham area
11. Waits River area
12. Danby Four Corners

Favorite Waterfalls

1. Lye Brook Falls, Manchester
2. Moss Glen Falls, Granville
3. Sterling Falls, Stowe
4. Bingham Falls, Stowe
5. Texas Falls, east of Hancock
6. Moss Glen Falls, Stowe
7. Hamilton Falls, Jamaica
8. Big Falls, near North Troy

Most Published Vermont Images

1. Jenne Farm, South Woodstock
2. View from Mount Philo
3. Any sugarhouse
4. Cloudland Road farm, Woodstock
5. Peacham Church
6. West Arlington Covered Bridge
7. Waits River village
8. Any barn with sheep

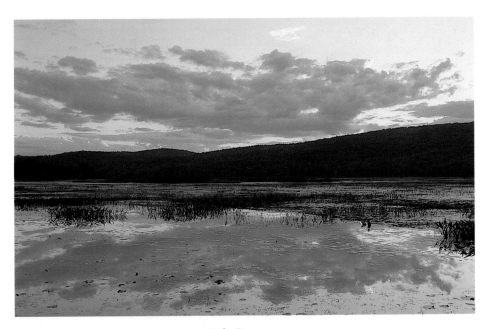

Lake Bomoseen

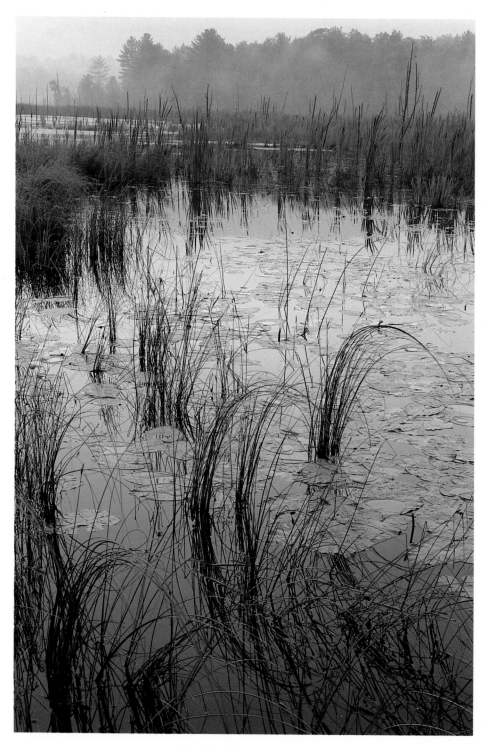

Kissick Swamp, Arlington

The best tool a photographer can have, besides photo gear, is a box full of reference material. Information is like chocolate—you can't have too much. So collect as much as you can, take notes in the margins, and your trips to come will be better.

Postcards

One of the best sources of information, wherever you are, is a postcard. Every town, no matter how small, has postcards of local interest for sale and a dozen people to tell you where the site is located. You're likely to find other locations not pictured this way as well. It means you're going to have to be friendly, but the extra effort will be worth it.

Maps

Getting lost has much merit for photographers, but most people want to know where they are and where they're going. Well, you are in Vermont and with our road system it's likely you're going to stay here. If this isn't good enough for you, try one of these atlases. Each is full of handy information as well as detailed maps.

Vermont Atlas & Gazetteer, 10th edition (Yarmouth, Maine: DeLorme, 2000).

Vermont Road Atlas & Guide (South Burlington, Vermont: Northern Cartographic, 2002).

Vermont Road Atlas (Round Lake, New York: Jimapco, Inc., 2001).

Guidebooks

Vermont is an outdoor-oriented state full of people who would rather be outside doing stuff than inside banging on a keyboard. Consequently, there are lots of outdoor guidebooks from which a photographer can glean much information. My favorites are:

Nature Walks in Southern Vermont by Mark Mikolas (Boston: Appalachian Mountain Club Books, 1995).

Nature Walks in Northern Vermont by Elizabeth Bassett (Boston: Appalachian Mountain Club Books, 1998).

50 Hikes in Vermont by The Green Mountain Club (Woodstock, Vermont: Backcountry Guides, 2003).

Vermont: An Explorer's Guide by Christina Tree and Sally West Johnson (Woodstock, Vermont: The Countryman Press, 2002).

Vermont Wildlife Viewing Guide by Cindy Kilgore Brown (Helena, Montana: Falcon Press Publishing, 1994).

Covered Bridges of Vermont by Ed Barna (Woodstock, Vermont: The Countryman Press, 2000).

Picture Books

Nothing warms a dreary day like looking at wonderful photographs of beautiful Vermont. There are two Vermont picture books that are outstanding, both done by incredibly talented yet disarmingly modest Vermonters (who like chocolate as well). One covers the cultural landscape of Vermont, and the other the natural landscape of Vermont. Consider them inspiration for your next Vermont outing.

The Soul of Vermont by Richard Brown (Woodstock, Vermont: The Countryman Press, 2001).

The Nature of Vermont by David Middleton (Woodstock, Vermont: The Countryman Press, 2003).

My Guide

Date:_____ Weather:_____

Location:_____

Notes:_____

Date:_____ Weather:_____

Location:_____

Notes:_____

Date:_____ Weather:_____

Location:_____

Notes:_____

Date:_____ Weather:_____

Location:_____

Notes:_____
